Guide to VCRs, Camcorders & Home Video

OTHER BOOKS BY GENE B. WILLIAMS, AVAILABLE FROM CHILTON

Chilton's Guide to Large Appliance Repair and Maintenance

Chilton's Guide to Small Appliance Repair and Maintenance

Chilton's Guide to Using and Maintaining Home Video Cameras and Equipment

OTHER BOOKS BY GENE B. WILLIAMS

The Homeowner's Pest Control Handbook (Tab)

Be Your Own Architect (Tab)

Wordstar 2000 (ComputerPrep)

Nuclear War–Nuclear Winter (Franklin Watts)

Guide to VCRs, Camcorders & Home Video

Gene B. Williams

Chilton Book Company
Radnor, Pennsylvania

Published in Radnor, Pennsylvania 19089, by Chilton Book Company

Cover photograph by Jim DeLion; styled by
Creative Associates; designed by Anthony Jacobson
Manufactured in the United States of America

Library of Congress Cataloging in Publication Data

Williams, Gene B.
 Guide to VCRs, camcorders, and home video / Gene B. Williams.
 p. cm.
 Includes index.
 ISBN 0-8019-8118-2
 1. Video tape recorders and recording—Handbooks, manuals, etc.
2. Camcorders—Handbooks, manuals, etc. 3. Home video systems—
Handbooks, manuals, etc. I. Title.
 TK6655.V5W552 1990 90-55317
 621.388′33—dc20 CIP

1 2 3 4 5 6 7 8 9 0 9 8 7 6 5 4 3 2 1 0

In memory of
Alan Turner

Contents

Preface

I've always been fascinated with buttons, switches and lights, even as a toddler. The fascination remained—and remains today. In my teens I fell in love with ham radio, at least in part because of all those knobs and switches. Eventually, I earned my license and got on the air.

When I became a freelance writer, the number of buttons needed to control things grew. Then came a job as associate editor for a magazine group, where we did most of our writing directly into a typesetting computer. With that also came a problem. The typesetter had the tendency to break down.

The editor, Tom Kay, had one in his home just as I did—and his, like mine, malfunctioned on occasion. We both had a natural drive to understand electronics, and a streak of stubbornness that made it impossible to let a mere machine get the better of us. Add to that being not just thrifty but downright cheap and we learned how to keep things running.

When I got my first PC, the skills I'd gained served me again. Topping the list—and most important—was the realization that I *could* fix most problems. A major barrier for most do-it-yourselfers is a reluctance to so much as *touch* those circuit boards.

Most available books on electronic equipment repairs were—and still are—aimed at those with technical training and a whole lot of expensive testing equipment. A book full of schematics doesn't help much if you've never learned how to read one. Nor does it help if you don't have the equipment (and training) to trace signals within a circuit.

Worse, these concentrate on the tiny percent of malfunctions caused by major electronic glitches, while ignoring the overwhelming number of times when the problem is that a good cleaning is needed.

Between them, these books address perhaps 2% of the population and 5% of the malfunctions.

I've done a series of repair and maintenance books for Chilton with this theme in mind. Although each of the books is of use to even a heavily trained technician, these people are not my target. *You* are. I'm assuming that you're as tired as I am of manuals that either treat you as an idiot or assume you to have a Ph.D. in electronics design.

I once described my goal with the series of books as follows: "I should be able to give a broken machine, and a copy of the book, to my grandmother. And using little more than

what she already has on hand, she should be able to fix it."

That's the goal of this book, too.

Can you do it? Of course you can! It's nowhere near as complicated as you might have been led to believe. At a recent seminar I gave, the audience consisted almost entirely of people with little or no technical background. I picked the least likely and most frightened person from the audience. Within minutes she'd opened a VCR and had given it a thorough cleaning. Her comment afterward was, "That was so easy!"

It *is* easy! You might (and should) surprise yourself at just how easy.

The predecessor to this book was highly acclaimed. The present version has been completely redone, page by page, and is (I think) much improved. There are also new chapters, and a lot of updated information.

Although this book concentrates on VCRs, enough information is given on camcorders and other home video equipment that you should be able to handle just about any problem that comes up. However, if you want more details on video equipment other than VCRs, and especially if you want to learn more about operating techniques, get *Chilton's Guide to Using and Maintaining Home Video Cameras and Equipment*. In it you'll find a number of tricks that the professionals use to make their movies better.

ACKNOWLEDGMENTS

My sincere thanks to a number of people. Right at the top is "Gordie"—my father, who built that switch/light box so I'd keep my hands off the TV set, and who ended up teaching me that nothing is impossible as long as you believe you can do it.

Alan Turner would have to be a close second. Through him, Chilton and I have had a long, friendly relationship. Also in support there are Elsie Comninos and Kathy Conover. Doing even one book, let alone a series, would have been far less enjoyable without their input and support.

Tom Kay served to drive home the, "Sure, you can do it!" attitude, not only with technical matters but also with putting those things into printed form. Jim Matthews was another "mentor" in these regards.

"Uncle Ben" Avechuco was of more help than he probably realizes. While I was digging deeper into the circuitry of video, Ben helped to bring it into perspective by showing the uses of video equipment.

Bob Patterson of *Silo* and Steve Szczepkowski of *Radio Shack* deserve mention for giving of their time to help with the project.

Last on the list, but critical to the whole, is Jim DeLion, who photographed not only the cover but most of the shots for the inside of the book.

The list goes on, but truly must begin and end with you, the reader. Your questions and comments are welcome (although a self-addressed *stamped* envelope would be appreciated if you wish a response).

Guide to VCRs, Camcorders & Home Video

Chapter 1

You *Can* Do It!

A number of survey results have indicated that as many as 85% of U.S. homes have VCRs. The reason for their popularity is no secret: If a program you want to see is on at 3 A.M., your VCR can be programmed to record it while you sleep. If NBC and CBS are both running blockbuster movies at 8 P.M., and you don't want to miss either of them, watch one while the VCR records the other.

Camcorders are almost as popular, making it possible to record family vacations and events; a camcorder costs as little as 2¢ per minute, whereas 8mm film will cost about $6 per minute (300 times as much).

That's where this book comes in: a second smart investment to protect your investment in equipment.

"BUY ANOTHER" MENTALITY

Despite increasing quality, things can go wrong with the VCR. The warranty will take care of costs for a while (from 30 to 90 days, depending on the machine and the manufacturer), but even when the VCR is under warranty you could find yourself facing certain incidental charges.

Some years ago the cost of a simple transistor radio was such that paying a technician for repairs was a worthwhile investment. Today repairs might total two or three times the cost of the radio. The technician will tell you: "It's not worth fixing. You can buy a replacement for less than it would cost to have me repair it. Just throw it away and buy another."

A transistor radio is relatively inexpensive these days, so it's easy to understand why people throw them away when they break down instead of spending the money for repairs. However, you might think that only someone foolish would throw away a $500 VCR. Even so, the "Junk it and buy another" philosophy for VCRs is common.

The rising cost of technical service is a prime contributor to the "Buy another" mentality. The common attitude seems to be that repair of many pieces of electronic equipment isn't worthwhile. The cost of parts, the cost of technical service, and the waiting time for the repairs often make it cheaper to buy a new unit if that unit cost $600 or less. One person who uses video recorders in his work commented, "If the repair costs me more than $450, and I can get a brand new machine for $500, why

bother? For just $50 more I can get a new machine, a new warranty, and all the updates."

Speeding us into this era of rapid obsolescence is the shortage of qualified service and repair technicians. Many people who are called "technicians" are in reality little more than "board changers." They can make a quick check of faulty electronic equipment and determine which circuit board is malfunctioning. To effect a repair, they usually replace the entire circuit board from their stock shelf and charge you $100, $150 or $200 for the board, plus labor charges, when the component that is causing the trouble might be only a 5¢ resistor, a 25¢ capacitor, or perhaps even a $4.00 integrated circuit (IC) chip.

Swapping circuit boards is so quick and easy that most shops have set a minimim of one hour as a labor charge, regardless of how long the job really takes. Therefore, ten minutes of actual work will *still* cost you the full hour fee of $35 to $60.

Before deciding to "junk it and buy another," get a second opinion. In one instance, a VCR owner was having problems with her machine and brought it to a shop. She was told that the heads had to be replaced at a cost of about $375, including labor. The unit had cost her $430 originally, so she was ready to trash the machine and get another. Fortunately, she decided to get a second estimate, and this time she managed to talk with a more honest (or more competent) technician. After a few minutes he thought the heads were just dirty. Five minutes and $15 later, the VCR was functioning perfectly. (She could have saved even that $15 if she'd done the cleaning herself.)

WHY BUY THIS BOOK?

User-Friendly

When you buy video equipment you are given an "operator's manual," which shows you how to use the machine. However, it rarely gives you the information you need to keep the player performing at its peak. Very few of those manuals even tell you how to clean the VCR, how to prevent problems from occurring, or how to do much of anything for that matter other than standard operation. For all of this, you are expected to rely on a service technician.

At the other end of the spectrum are those books and manuals that assume you are trained in electronics already and have a benchful of testing gear. They are often filled with detailed schematics of the various circuits (or samples of them). This means that the "average person" is still left out.

Sure, you could spend the money to buy a dual-trace oscilloscope, signal and color generators, digital logic probes and on and on and on. You could spend the time and money to take courses in electronics and in VCR repair. But the simple truth is that you don't need these things for well over 90% of the problems you'll encounter. That 90% is the center of this book; the information is aimed at the 98%+ of the VCR owners who don't have all that training and equipment on hand.

The VCR is a precision electronic-mechanical unit and can therefore be intimidating. Other books you've looked at, with page after page of circuit schematics, may have convinced you that you have no business fiddling with your VCR; don't let that happen. Many of malfunctions that cause your unit to fail are mechanical in nature. Very few involve the electronic circuits and/or components. Chances are very good that you can fix the problem with minimal effort and with no more tools than a screwdriver and your fingers.

Even an untrained owner can be shown methods for investigating the cause of the most common machine malfunctions. A great many corrective measures may be undertaken by the operator with high-priced service technicians needed only for the repair of major troubles. The more that you can learn in the way of correcting minor problems, the more you will be

able to save in time, money, and possibly ruined recordings.

The two primary causes of problems are dirt and operator misuse/neglect. Not only can you find and fix most malfunctions, you can often prevent them from happening (or at least reduce the occurrences). Just as you maintain your personal automobile with periodic servicing, so should you in taking care of your VCR; and as with your car, simple preventive maintenance will help avoid serious and costly problems.

With this book, and a little time (VERY little), you can maintain and even repair your video recorder, *even if you have no prior technical or mechanical background.* You don't have to be at the mercy of the repair shop, nor is there any reason to toss $500 or more of equipment in the trash. If you have enough "skill"

to replace a burned-out light bulb, or to use a screwdriver, you have a sufficient background to use this book.

In addition, you'll learn how to recognize when the malfunction is something best left to a professional technician. When this time comes (if it comes), you'll also have some idea of what has gone wrong, which will both reduce the cost of repair and reduce the chances of being "ripped off" by a dishonest or less than competent technician.

Safety Is Placed First

Most video recorders have a sticker that says something like, "WARNING—SHOCK HAZARD—DO NOT OPEN! No user serviceable parts inside. Opening this cabinet will void all manufacturer's warranties." Even after the warranty has expired, this tag works to de-

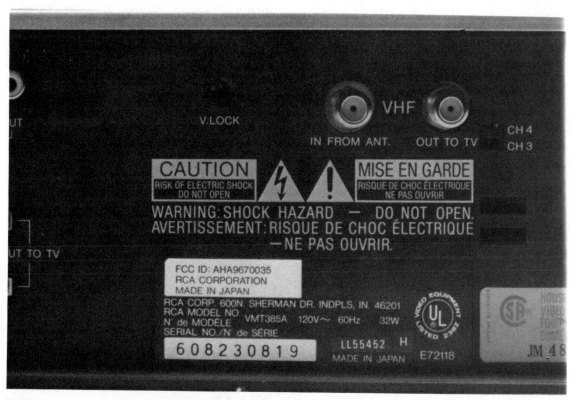

FIGURE 1–1 Always read the warning sticker; it includes valuable information.

ter the end user from attempting even the simplest repairs. There *is* danger under the cover, but very little IF you use some common sense.

Unlike a television set, a video recorder operates on low voltage. The most dangerous spot is where 120 volts comes into the unit. By carefully following the instructions in this book, that will never present a danger to you. This book will show you exactly what to do—and what *not* to do.

TOOLS AND MATERIALS YOU'LL NEED

You probably already have most of the tools needed. Even if you don't have them, the cost is generally small. Most are available at any electronics supply house, such as Radio Shack, and some can be purchased at your local drug or grocery store. In the listing on pages 7 and 8 part numbers and costs are given when possible.

There's no need to go out and buy the complete set of tools. You can start with the basics and add more when the need comes up. At very least you're going to need a Phillips-head screwdriver with a medium point. This will be needed to get into the cabinet. The same screwdriver might be suitable to remove other parts inside (such as the metal shield over the head assembly); if not, you might need one with a smaller head.

You should also have on hand at least 2 blade-type screwdrivers of different sizes. The cost isn't important, but the screwdrivers should be sturdy enough to turn the screws without bending, breaking, or flaking. (Inexpensive screwdrivers are often coated with a substance that flakes off. Don't use these!) The blade of the screwdriver should fit nicely into the slot of the screw. Trying to use the wrong size (or wrong type) screwdriver can cause damage.

Needlenose pliers come in handy for a variety of tasks. They can be used to reach into small places and even to retrieve parts that have been dropped. Regular pliers, in a small size, are great for holding things that your fingers can't. For both types, it is much preferred that you use tools with insulated handles. This protects you and the machine. As with the screwdrivers, be sure to get tools that won't flake.

A set of hex wrenches may be required, depending on the machine you own. Buying a complete set is better and less expensive in the long run than trying to buy individual wrenches. Again beware of cheaply made tools that can flake or bend.

A set of nutdrivers are not essential but come in so handy that we chose to list them. Nutdrivers are like socket wrenches attached

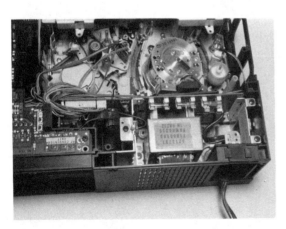

FIGURE 1–2 The inside of a VCR. Always be careful when working around the power supply.

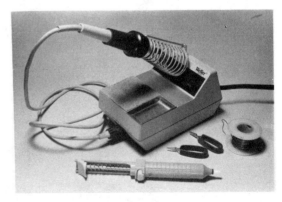

FIGURE 1–3 Soldering iron, resin-core solder, desoldering tool, and heat sinks.

to a screwdriver handle. They are used to remove or install the various nuts that hold things together.

The standard cleaning fluid is very pure isopropyl alcohol. *DO NOT use rubbing alcohol.* Rubbing alcohol has water and may contain oils that can harm the video equipment. You'll have to ask for the technical grade isopropyl alcohol specifically, preferably of 98% or better purity. This is available through your local druggist. Liquid freon, available through any electronics supply house, can also be used and even has some advantages in that it can be used on rubber parts, whereas alcohol cannot.

Cotton swabs are useful in a number of ways. The swabs can be any type, as long as the cotton on it is tight and won't leave messy threads inside the machine. (This is *not* a place to save pennies.) Swabs should be used only for cleaning the tape guides and other mechanical parts. NEVER use them for cleaning the heads. Doing so brings the risk of damaging the heads, and also of getting cotton threads caught in the spiral groves of the head assembly.

Special foam pads meant specifically for head cleaning are available. You can also use optical-grade chamois. The latter, however, means that you have to exercise caution in that your finger will be pressing against the head assembly. (Very little pressure is needed. Let the alcohol do the cleaning, not pressure.) (For more information on cleaning the heads and other parts inside the VCR, see Chapter 7.)

For convenient head cleaning or for those pieces of equipment that don't allow easy (or safe) access, you can use one of the many head cleaning kits that are available, generally at a cost of between $10 and $20.

A head cleaning cassette can save you time and bother, but you'll pay as much as a dollar per cleaning. Most qualified technicians don't recommend using these cleaning tapes. It's felt that they do only a partial job of head cleaning, and that they are inefficient in cleaning the machine's tape guides. Further, some specialists

believe that the cleaning tapes can actually leave a harmful residue on the tape guides and the head drum, which can swiftly lead to a sharp deterioration in the performance of your VCR.

Another handy substance to have around is a spray contact cleaner. DO NOT use a cleaner that has a lubricant in it, as this will leave a residue on the contacts.

Sometimes a belt will begin slipping. Usually this means it's time to replace the belt. You can "dress" the belt, and bring it back to life, use beeswax. This can be purchased for very little cost at hardware stores and most drugstores. Do keep in mind, however, that dressing the belts is only a temporary cure. It's wise to find out ahead of time who can supply replacement belts. Although there's generally no need to get a set of replacements before they're needed, you may wish to do so if your machine is more than a few years old, especially if they're hard to find.

A small container of light oil will be needed for lubricating some of the moving parts. You can get it many different places, including at many small appliance stores. *DO NOT attempt to use ordinary automotive motor oil.*

Some special precautions are needed if you are going to lubricate anything in the VCR. Just a part of a drop of lubricant in the wrong place can cause serious trouble. An applicator with a needle tip will help. Even then, use extreme caution. This is one of those times when the rule is, "When in doubt, don't!"

A multimeter is a device that can check for voltage, resistance, and current (under certain conditions). It is sometimes called a VOM, for volt-ohm meter, its two most important functions. Although you can spend several hundred dollars on this meter, one costing $20 or less will do just fine.

For any component replacement work inside you'll need two tools. One is a soldering iron (20–25 watt). The other is a desoldering tool, sometimes called a "solder sucker" (which describes its function quite well). It comes in

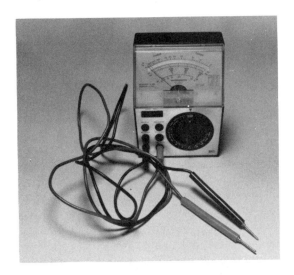

FIGURE 1-4 A multimeter is essential for troubleshooting.

soldering tool is then used to remove the melted solder, making component removal much easier. Some components, such as IC chips, cannot be removed without this tool.

For safer soldering, a set of heat sinks are nice to have. These are small metal clamps that draw the excess heat away from the circuitry, and thus protect your machine. Heat sinks also help to protect new components while you solder them into place. A component such as a transistor or IC chip tend to be rather sensitive to heat. A pliers, such as a needlenose, can also be used, but the heat sinks are much better as they don't require that you hold them in place.

NOTE: If you're going to be doing any soldering, learn the correct way to do it first. It's not as easy as it sounds, and you can cause considerable damage if you're careless.

The components are generally quite small. As you solder or unsolder them, the heat can burn your fingers. Regardless, you'll find yourself wishing that you had an extra hand or two when carrying out some repair jobs. A small C-clamp, small vice or one of the special circuit board holders will take care of this for you. The $8 or $9 cost of the tool is well worth it, even if you are going to do just one repair. The savings in frustration alone are worth the cost. Be sure to pad the jaws if they're not already padded. (Some folded paper towel will do.)

A 1/32" drill bit can clean out clogged circuit board holes. You may even be able to find a bit that works as an attachment for a soldering iron at one of the larger electronics supply stores. One of the small hobby drills, such as the Dremel MotoTool, is better for this job than a standard hand drill, but a hand drill will work if you're careful. Most of the time you won't be actually drilling anyway—just using the drill bit to clear a circuit board hole that is clogged with solder. Drilling is a last resort.

If at all possible, keep some spare cables and connectors on hand for external connections. The cost is small compared to the frus-

several different types, from a simple squeeze bulb to a fancy syringe. Virtually all electronic parts in the video recorder are soldered into place. If you have to change one, first you must be able to melt the old solder joint. The de-

FIGURE 1-5 A "Third Hand" is a worthwhile investment.

Taking care of a VCR is common sense. It's not difficult. If you can read and follow basic instructions, you can increase the operating lifetime of your VCR and save considerable amounts of time and money doing it. There is rarely a need to toss out a malfunctioning machine.

The first step is to learn how to properly maintain the equipment. If you take just a little bit of time in maintenance, the number and seriousness of malfunctions will be greatly reduced. This maintenance includes the machine and the tapes.

Before beginning any of the procedures be sure to read the instructions thoroughly and follow each step exactly as described. Go through the steps mentally before actually doing anything. This is especially important if you've never attempted to maintain sophisticated equipment before. There's no reason to fear it. You *can* do it. By going slowly and thoughtfully, you reduce the chances of accident and increase your own understanding.

tration of having one of the cables cause trouble just as you're about to make an important recording.

With ordinary care and a bit of logic, you can take care of many of the repairs and 100% of the normal maintenance.

Things You Will Need

PART	PART #	COST
Screwdriver(s) (Phillips)	any	$3–6 each
Freon	RS 44-1171	$3.59
	-or-	
Denatured Alcohol (99%)	tech grade	$3/pint
Cotton swabs	any	$1.50
Foam-tipped Swabs	RS 44-1094	$2.09
	-or-	
Head Cleaning Pads	any	$2.00
Contact Spray Cleaner	RS 64-2322	$2.99
Light Lubricating Oil	RS 64-2301	$1.69
Multimeter (VOM)	RS 22-201	$19.95

Things You MIGHT Need

PART	PART #	COST
Head Cleaning Cassette	(VHS) RH 44-1185	$12.95
	(Beta) RS44-1186	$12.95
	(8mm) RS 44-1147	$10.95
	(VHS-C) RS 44-1187	$9.95
Needlenose pliers	any	$4
Screwdrivers (2 blade-type)	any	$3-6 each
Regular pliers	any	$3.50
Hex wrench set	any	$3
Nut driver set	any	$6
Bee's Wax	any	varies
Lintfree gloves	any	50¢ +
Small Magnifying Glass	any	$1−5
Soldering Iron (20−25 watts)	any	varies
Solder (resin-core ONLY)	RS 64-001	$.89
Heat Sinks (various)	any	varies
Desoldering Tool	RS 64-2086	$2.59
1/32″ Drill Bit	any	various
Spare Fuses	various	25¢ + each
Spare belts	various	$1 + each

Chapter 2

Safety and Preparation

If you're going to be working around electricity and complicated (and delicate) equipment, the first thing to learn is how to do it safely. Although the voltage and current in most of the VCR presents minimal danger to you, there are spots that can be dangerous—even lethal.

The same safety procedure can also save your VCR. Being careless can cause an entire circuit to go up in smoke (sometimes literally). The mechanical parts must operate perfectly if the VCR is to work. When working with delicate equipment, it's easy to bump or bend something, or otherwise cause damage so that a part can't do its job properly.

Awareness of safety procedures is critical—to the point that if you can't pay attention to them, you really *don't* have any business attempting even the most routine maintenance, let alone troubleshooting and repairs. Basic precautions and common sense will see to it that neither your safety nor the VCR is jeopardized.

YOUR SAFETY

The first and most important consideration is your own safety. If you totally destroy the VCR, it can be replaced. You can't be. There is no such thing as being *too* cautious.

Every year a number of people are accidentally electrocuted. Almost without fail, the cause was simple carelessness—thinking that safety is for "the other guy." Most electronic equipment that gets current from a wall socket will have a sticker telling you to stay out. Quite often the warning will be accompanied by "No User Serviceable Parts Inside." The purpose of these stickers is to discourage such people (careless people) from poking around inside where they might come into contact with a dangerous voltage.

Warnings carried on most television sets say that even when the unit is unplugged from the wall, if you probe inside the chassis you may be exposed to potentially lethal shocks. Adhere to this warning. The operation of a video tube in a television set requires extremely high voltage. Capacitors can also hold dangerous voltages. In both cases, the stored charge can last for long hours—even days—after the set has been turned off and unplugged. A finger stuck in the wrong place inside a television can be lethal.

A VCR does not have a picture tube and therefore does not need to generate such large

FIGURE 2–1 Be especially careful where the 120 volts AC comes into the machine.

voltages. The normal 120-volts AC from the wall socket is used to operate the motors and servo–mechanisms for the various functions of the VCR. These present the only threat to your own safety. With precautions, working inside the VCR is no more dangerous to you than working with an electric lamp. Still, the dangers of electricity cannot be taken lightly.

Tests were performed by the United States Navy to find out what effects take place in an electric shock with the standard 60 cps (cycles per second) AC current that flows through your walls, out the wall outlet and into equipment (such as your VCR). These tests have shown that it takes just a tiny amount of current to kill. A current value of just one milliamp (.001 amps) can be felt. A current of 10 milliamps (.01 amps) causes the muscles to become paralyzed, making it impossible for the person to let go of the source of the shock. A current of a tenth of an amp is usually fatal if allowed to continue for more than one second.

The amount of incoming current is limited only by the wiring and by the circuit breakers or fuses. Normally, the current can be a steady 15 or 20 amps. For a short time, until the wires melt or the circuit breaker or fuse blows, the current is almost limitless. If you are careless, your body could absorb several thousand times the lethal amount of electrical power.

SAFETY RULES

1. Work Slowly and Carefully
2. Remove All Jewelry Before Starting
3. Use the "One-Hand Rule"
4. Insulate Yourself From the Equipment
5. Insulate Yourself and the Equipment from the Surroundings

Technicians are taught (or should be) two precautions on their first day in training school. The first is to remove all jewelry, watches, metallic objects, etc. from around the hands, wrist, and neck before attempting to do any electrical service work. Not only can a dangling bracelet or necklace conduct electricity and give you a serious shock, it can also act as a conductor between a hot wire and the grounded chassis or another ground and may cause a short which can seriously damage the unit.

The second precaution is the one-hand rule. Keep one hand in your pocket at all times when investigating or probing an electronic device that is energized (has current flowing in it). This may sound at first like a strange, if not silly, suggestion. Yet electricity, to shock, must move from one point to another. Current must flow from a finger that touches an energized wire to another spot. If one hand is holding the metal chassis of the VCR, or some other ground, and a finger of the other hand touches a high voltage line, the flow of current will instantly pass from one hand to the other and through your body. If you keep one hand in your pocket, current can't flow through your body from hand to hand. By keeping the free hand in a pocket, you won't be as inclined to reach out and touch something you shouldn't.

Wear rubber soled shoes to insulate you from the ground. The unit should be on an insulated surface (i.e., a dry, nonmetallic table). This helps to reduce the risk of having a dan-

gerous current flowing through your body or down through your feet.

VCR SAFETY

The power supply changes the 120 AC to the needed values of DC to operate the circuitry. The voltages used for amplification, tuning and basic circuit function of the VCR are generally very low in value, with 5 volts and 12 volts DC being the most common. Even with the VCR plugged in and the power on, these circuits present no danger to you.

The potential danger to the VCR and its circuits is very real, however. An accidental short circuit, such as would be caused if you touch a screwdriver or something else made of metal (you've already removed all your jewelry, right?), can cause damage faster than you might believe possible. The circuits are designed to have a flow of current in a particular manner. A short circuit changes this. All of a sudden a component that is meant to carry just 1 or 2 volts (or less) can be hit with 12 volts and a higher amperage.

One person I know was probing the power supply outputs. His hand slipped and the probe touched the wrong spot. Before he even realized that he had slipped, an entire circuit board was ruined.

It's a good idea to turn off the power to the unit while attaching test leads, especially if you've had little prior experience with a VOM or probing. Apply the voltage to take the reading, then disconnect the power before removing the leads. This will help prevent accidental shorts.

In addition to electronic damage, there is the possibility of physical damage. Many of the parts inside are delicate. Probe carefully and keep your fingers and anything else that might be contaminated with dirt or grease out of the machine entirely. A fingerprint and the oils of

a finger can ruin certain parts just as surely as can a hammer.

The rotating record/playback heads, for example, are extremely sensitive, especially when they're moving. NEVER touch them with your fingers. (There is no reason to except for a head replacement. That's a job that must be left to a professional technician, who can align the new head assembly properly.) The only thing that should *ever* touch the heads are cleaning fluid and the cleaning pads.

Haste is the biggest enemy. *Go slowly.* Look things over first. The best way to make mistakes is to tear into the machine without first thinking out what it is you're going to do. Sketches will help, as will a sense of organization.

Take your time and make sure that you know what you are doing *before* you do it. If a part you're trying to remove seems stuck, there's a reason. Trying to force it almost guarantees that something will be damaged.

Video tape recorders are designed to be operated in a horizontal position. If the power is on with the unit tilted on its side, there is the possibility that some of the motors that are mounted may be forced out of line by their mere weight, causing drive belts, springs, levers, or servo–mechanisms to slip out of place. The machine could jam or become damaged.

Keep movement of the VCR unit to a minimum, both while you're working on it and during normal operation. This is obviously more important with the tabletop models than with the portables, but *all* VCRs should be treated with care, especially while power is flowing through them.

A final consideration in positioning the machine concerns the air circulation needed to keep the VCR from overheating. Most units have vent holes at various locations on the cabinet, usually above and beneath. These vents allow the release of heat generated by the components. An unwary user might set the machine on a table or stand in such a position that the

vent holes are blocked by a lip or by other objects on that table. The result is overheating and the result of overheating is almost always damage to the unit.

An extreme case of this involved one user who was so concerned about dust getting into his machine that he used masking tape to cover all the holes to block out the dust. About a week later there he was, burned out unit in hand, wondering why in the world the manufacturer would build such an unreliable product.

OPENING THE CABINET

Opening the cabinet is relatively simple. Go slowly and use your common sense. If the cover doesn't come off easily, find out what's holding it. DO NOT force it!

As always, your own personal safety is your first concern. You're unlikely to encounter dangerous voltages outside the unit. Inside there are various "hot spots" where you could accidentally touch a live 120 volts AC. The power should be off and the plug disconnected *before* an attempt is made to remove any cover. This is especially important when removing the bottom cover. Not only is this done to protect you from potential shock, but to prevent possible damage to the VCR itself.

WARNING

Removing the cover may void the warranty. Carefully read the warranty information that comes with your machine before even thinking about removing the cover. If opening the cabinet voids the warranty on your particular VCR, put this off until after the warranty has expired, or convince the salesperson or serviceperson to open the cabinet.

Most often, the top cover is held in place by two Phillips–head screws on the top and at the back. Sometimes the holding screws are on the sides; sometimes one or more will be on

FIGURE 2–2 Removing the upper cover.

the rear of the machine. A visual inspection will tell you.

In almost every instance, the front of the cover has a lip that slides under the front panel of the VCR. After you've removed the two screws, grasp the cover at the sides toward the rear and lift. It should come off easily. If it doesn't, look to see if there are other screws or catches.

Inside you'll usually see a metal shield covering the head assembly. This will have to be removed to clean the heads and those mechanisms that load, unload, and move the tape. (Some VCRs have a circuit board covering this area.) The shield is usually held in place by 2 to 4 Phillips–head screws and some catches. Once

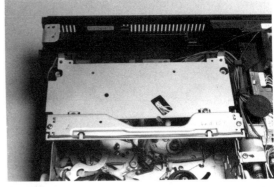
FIGURE 2–3 Most VCRs have a metal shield over the head assembly.

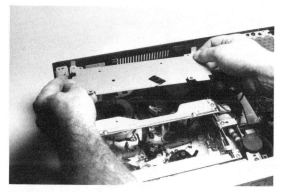

FIGURE 2–4 Removing the shield.

again, examine the situation carefully. How the shield is held in place will probably be obvious. If it doesn't come out easily, look carefully, and DO NOT force it.

The bottom cover isn't quite as simple. Most units have this cover held in place by screws in each corner. **Caution is needed:** the bottom might also have screws that hold other components.

If you're uncertain, only loosen the screws, starting with those in the corners. You should be able to tell if you're dealing with the right screws.

A common way for the first–timer to go about opening the VCR is to make the screws come flying out and into a disorganized pile. Once the covers are finally removed, the owner is amazed that all sorts of things are falling out.

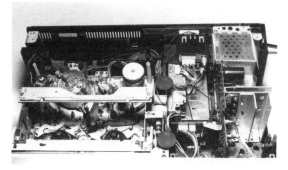

FIGURE 2–5 Inside the VCR with cover and shield removed.

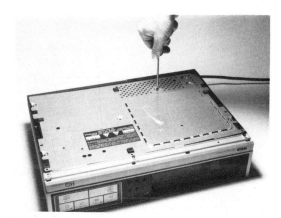

FIGURE 2–6 Removing the bottom cover.

When it comes time to reassemble . . . "Now where did this go?"

The key to successful repair and maintenance is care. Don't be in a hurry. Plan every step before you take it. Whenever applicable, make sketches and notes. Keep the parts you remove organized. A muffin tin, for example, is great for organizing parts.

When you're looking to buy a new VCR, you might be able to have the salesman or serviceman show you how the covers come off. If you watch the serviceperson remove the cover, you'll see where the holding screws are, and what tools are required.

If it is obvious that there is some kind of a snap or pressure catch holding the cover or dust plate, use a great deal of caution in trying to pry the cover up with the blade of a screwdriver. Always be aware that you might be trying to pry something up when an unnoticed screw is still firmly attaching that something to the main chassis.

PREPARING TO WORK

Preparation is a crucial part of safety. Understanding your machine is the best way to prepare for repair and maintenance work. If you take the time to learn how the unit oper-

ates, you'll be more likely to produce safe successful results.

Even if you don't intend to clean anything, you can gain a better understanding of how your unit does what it does by looking inside as it operates. Remove the top cover as soon as possible after the warranty has expired. (Keep in mind that the power will be *off* when removing the cover and *on* when watching the VCR operate. Be careful!) For example, as you insert the video cassette and press "Play," you'll see the automatic loading and threading machinery in action. The idea is to become familiar with your VCR *before* something goes wrong.

Carefully study the inside of the machine. Make a note of the positioning and alignment of the various motors and the belts used to drive the mechanisms in the VCR. If possible, write down the position and size of each belt, drive wheel, pulley, and fuse so that you will be able to obtain replacements when necessary. (*Note: Most of the belts and motors are beneath the machine. Removing the bottom cover will again require taking out 4 or more Phillips–head screws.*)

It is important for you to see how the belts are positioned and how all gears and pulleys engage when the machine is working properly.

If the first time you open the VCR is after you have encountered trouble and the problem is a broken belt, it is sometimes difficult to determine the exact tracking position for the replacement belt.

While the unit is open, try to determine the proper method for removing and replacing all of the mechanical parts, belts, and fuses around which you feel capable of working. During this inspection, be careful not to probe with pressure at any point on the mechanical parts of the VCR. The alignment of most of the levers, tape guides, servo–mechanisms, and the tracking wheel is fairly critical. Even if bent just slightly out of shape, a disoriented piece could cause a troublesome malfunction in the unit.

Manually (and carefully) check the tension of the various belts and springs. After many hours of operation, these belts will have the tendency to become worn and stretched, just like the fan belts of an automobile. Knowing how things are *supposed* to look and feel can help you spot problems later.

Slightly stretched or worn belts may be temporarily aided in their work by a careful application of resin or beeswax to the *inner* surface. This can keep the drive belts from slipping, at least as an emergency procedure.

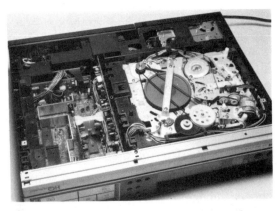

FIGURE 2–7 Make a note of all belts, gears, pulleys and fuses.

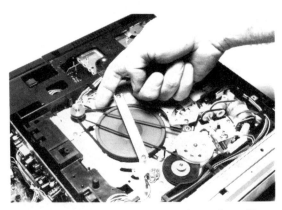

FIGURE 2–8 Manually check the tension and condition of the belts each time you open the case.

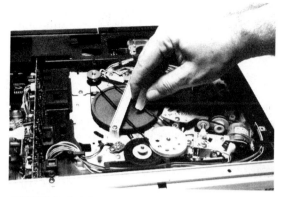

FIGURE 2–9 A light application of resin or beeswax can temporarily halt belt slippage.

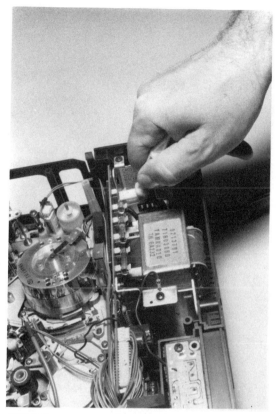

FIGURE 2–10 Use a fuse puller to make the job easier and safer.

Locate all fuses and breakers in your unit as you're making your initial study of the VCR. All too often these are concealed.

Two commonsense alerts are worth restating here:

1. *Never replace any fuse with a direct shorting wire or with a fuse with higher current breakdown value.* If the fuse is rated at 1 amp, replace it ONLY with another 1 amp fuse. Not following this precaution could lead to more serious damage to the machine, and could even create a hazard to you. A fair number of electrocutions and home fires result by people who don't bother to show common sense when replacing a fuse.

2. *Never change a fuse while there is power flowing.* Unplug the machine before attempting the replacement. Chances are good that there is 120 volts going to the fuse junction block. Sticking a finger or screwdriver there while the machine is plugged in is like sticking the same thing into a live wall outlet. Normally the fuse is on the "safe" side of a switch, but don't bet your life (literally) that it is.

If the fuse is held tightly or is not easily accessible to your fingers, spend the extra dollar or so to get a fuse puller. This is safer to use than a screwdriver and *much* safer than pulling on the fuse with your fingers.

Pay close attention to the various connectors, inside and out. Those inside, despite being essentially permanent, can become dirty or damaged. Normally all you have to do to take care of problems with these connectors is to unplug, clean, and plug again.

The external connectors might be different. Every time a cable is attached to one of these connectors, some form of twisting or pushing force is applied. Eventually, this movement may cause one of the inner wires to break or become shorted.

The easiest and fastest test is to try another cable you know to be good. If that doesn't solve

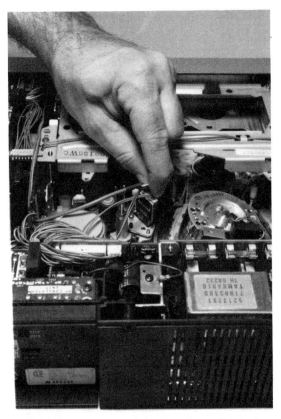

FIGURE 2–11 Check the connectors to see if any wires are broken, loose or twisted.

are very much aware that they can "freeze" due to an accumulation of dust or moisture after a year or two of operation (or storage), causing the machine to malfunction or quit.

A drop of oil placed on the motor shaft (WITH THE POWER OFF) might temporarily restore a frozen motor to operating condition, even if that motor is not meant to be lubricated. It's a temporary cure, however. If you get the motor working again, it might continue for just a few days or perhaps for a few years.

Extreme care must be exercised when lubricating the VCR. There are mechanical points—servo–mechanisms and solenoids (spots where is moving metal on metal or metal on plastic)—that may be improved with a very light use of machine oil. However, this same oil is extremely *damaging* to video tapes and video heads.

NO lubricant should be allowed to get on any of the tape guides, on any video tape, or come anywhere near the rotating video heads. If your hand is shaky, or if the nozzle of the oil container allows anything but the tiniest and controlled drop to come out, don't attempt any lubrication. Just a part of a drop in the wrong place can cause considerable damage both to the machine and to any tapes run through it.

If any excess oil does happen to spill or drop on a critical area of the machine, a cotton swab or one of the specially manufactured head

the problem, open the case and examine the connector to see if a wire has broken or has been twisted into a shorting position. You may be able to make the repair by simply untwisting or resoldering the wire rather by having to replace the entire connector. Also make sure that the nuts mounting these connecting sockets are firmly screwed down. They may have become loosened, either through overuse of the connector or during transport of the VCR.

Before closing up the VCR, study any potential lubrication points. Most modern VCRs are manufactured with "sealed" motors and solenoids, units that are designed to work for many years without lubrication. However, technicians experienced in working on these devices

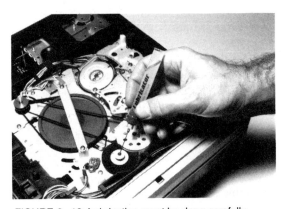

FIGURE 2–12 Lubricating *must* be done carefully.

cleaning pads along with either head cleaning fluid or pure isopropyl alcohol can help to clean the accidentally contaminated surfaces. Again, proceed with caution and move slowly. Be sure to clean everything completely. (See Chapter 7 for more details on cleaning.)

KNOW YOUR LIMITATIONS

Although you can handle 90% and more of all repairs and maintenance, there are some things best left to professionals. It's important for you to recognize your own limitations. Be confident that you *can* handle most of the problems that arise. At the same time, don't try to tackle something that is beyond your capabilities.

You will most likely be able to handle all of the regular maintenance as well as such basic malfunctions as blown fuses, worn drive belts, pulleys or pinch rollers, malfunctioning connectors, or broken interconnecting cables. This makes up almost everything that goes wrong. The time comes, however, when the skills of a professional are needed.

You should also leave to the professional anything that is too complicated for your experience. For example, many of the circuits require special equipment to test or repair.

Alignment

Alignment is one of the most common things for which you'll require a professional technician. Fortunately, you don't need to worry about head alignment very often. Alignment is performed during manufacture and it isn't needed again until about 2000 operating hours have passed, if then. That's like watching or recording 1000 two–hour movies. If you watch a double feature every single night of the week, it will take almost 3 years before the 2000 hours have passed.

Usually a special (and expensive!) alignment tape is used, along with some associated (and expensive!!) test equipment. The alignment tapes are produced by all manufacturers and are normally available only to authorized dealers. They are used for checking and then touching up the playback/recording quality of video recorders. Alignment tapes are *not* used for troubleshooting because they can be damaged all too easily by a malfunctioning machine.

Because alignment is needed so seldom, because it requires expensive tape and equipment, and because you can cause considerable damage if you don't know exactly what you're doing, *leave the job to a professional*. It will actually cost you less and will be safer.

Soldering

Unless you know how to handle a soldering iron correctly, it's best to leave any complicated soldering to a professional. The boards are sensitive to heat and can be damaged all too easily. The same is true of certain components, such as the IC modules.

Be confident that you *can* handle the tasks of repair and maintenance. But be honest about your limitations.

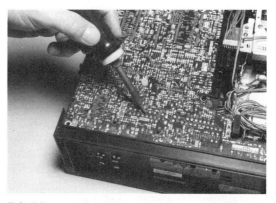

FIGURE 2–13 The circuit boards can be damaged by heat, making your attempt to save money very expensive. If you're not competent at soldering, confine yourself to replacing only the 2 and 3 lead components. Or take the job to a professional.

COMPONENT REPLACEMENT

Sometimes you'll be able to track the fault to a single component. Perhaps a 5¢ resistor has gone out, or maybe the problem is with a 30¢ transistor. You don't necessarily have to throw away an entire circuit board.

Obviously, tracking a malfunction to an individual component requires some training and often some special testing gear. There are also times when the problem is easily spotted. Either way, repair on a component level also requires that you know something about soldering. If you don't, it is strongly urged that you either *learn* and then practice ahead of time or that you leave the soldering jobs to a professional.

Desoldering and soldering of most two-lead components (resistors, capacitors, etc.) is fairly simple. Keep in mind that the circuit can be damaged permanently by too much heat. Don't let the soldering iron stay in contact with the board for more than about 5 seconds. A desoldering tool and needlenose pliers will come in very handy.

Working with components that have more leads can be a bit tricky. First there is the physical matter of having more leads with which to fiddle. Also components that use more leads tend to be more complex, and thus more prone to heat damage. It isn't difficult at all to destroy a transistor with too much heat.

At the same time, too little heat will give a bad solder joint. Operation of the circuit will then be sporadic at best, if it works at all. In some cases it's possible that further damage will be caused to other components.

IC modules are sensitive not just to heat but also to static. Handle them with great care, and avoid touching the leads with your fingers or with anything that can conduct. IC extracting and inserting tools will help to prevent this from happening, and will also make the job of replacement easier. If you're going to be soldering around the IC modules, it's also a good idea to use one of the special soldering tools designed for electronic circuits. These have grounded tips to make sure that static doesn't build up on the tip and damage sensitive components.

Replacement of any component requires an exact match. If you're not sure how to "read" the value of a component, get one of the many books available on basic electronics.

Some components have polarity. Installing such a component incorrectly can cause severe damage. In some cases, it can also cause a dangerous explosion. Electrolytic capacitors and some IC chips are well known for this.

Diodes and electrolytic capacitors are examples of polarized two–lead components. The transistor is probably the best example of a three– or four–lead component with polarity. IC modules can have any number of leads coming from the package, with the placement of each in the circuit important. Pay very close attention to the polarity of the component you remove. Even if the circuit board indicates the polarity, take notes and make sketches as you go along.

MAINTENANCE

The best way to handle problems is to avoid them. Regular maintenance will take care of this, and will greatly reduce the cost, both in time and money, that you spend in keeping your VCR working properly. (A more complete discussion of maintenance is in Chapter 7.)

SUMMARY

Use caution whenever working around electricity. Keep in mind that even those currents that can't hurt you can severely damage electronic circuits of your VCR.

Wear rubber soled shoes, have the machine being worked on resting on an insulated tabletop or surface, avoid water or any type of moisture, and use an insulated probe to touch any surface or area of which you are unsure.

Always follow the "One-Hand Rule" to prevent your body from becoming a part of a pathway for electrons. Keep safety in mind—first your own and then the machine's.

Work slowly and carefully. It's better to take an additional half hour to complete a job than to spend an entire day trying to make up for mistakes made in haste.

Take the time to learn ahead of time and you're less likely to run into troubles later. As soon as possible, remove the cover and watch the VCR in operation.

Learn to recognize your own limitations. Although you can easily handle the majority of problems that come up, there will be times when paying the professional's fee will be the best and least expensive method.

Above all, remember that the best solution is to prevent problems from happening in the first place. This is done by a regular schedule of maintenance.

Chapter 3

VHS or Beta? New or Used?

The first video tape machines were reel-to-reel. Today these exist only in recording and television studios. They're simply too expensive and ponderous for home use.

Along came Beta, the first home system that used a cassette instead of a reel. Within a very short time quality improved. Then came VHS, another cassette system. Competition and public demand drove quality and choice up, and prices down.

As the battle of quality continued VHS introduced HQ (high quality) circuitry for improved imaging, at which point Sony responded with Beta Hi–Fi, which was answered with JVC's Super–VHS. Now we have ED Beta and the miniature Hi8 with resolution that matches S–VHS.

Meanwhile, camcorders were becoming more and more popular. In 1985 the 8mm format was introduced. This miniature version made it possible to build camcorders small enough to be held in the palm of your hand. The major problem was that resolution in the first units was fairly pitiful. That led to the development of new methods for manufacturing, especially of the tapes. As mentioned above, Hi8 now boasts 400 lines of resolution, which comparable to that offered by Super-VHS. In a recent testing by *Consumer Reports*, the 8mm format got the best scores, even knocking out S-VHS and ED-Beta.

JVC came out with its own miniature, VHS-C, with an adaptor that would allow the tinier cassette to be played in a standard machine.

Your choices in new equipment is nothing short of incredible; perhaps "confusing" would be a better term.

VHS OR BETA

Two basic formats for video recorder design have been battling for consumer acceptance almost since the invention of the VCR. (*Format* refers to the general plan or arrangement of the device.) Ask around and you'll find people, including highly qualified technicians, who will speak vehemently both for and against these two basic systems.

The Sony Corporation was the first to mass produce video cassette recorders. Engineers at Sony invented the Beta format. Soon after, JVC (Japanese Victor Corporation) developed VHS.

Today, almost all VCRs sold in the United States use one of these two formats or a variation of them. (Coming up fast, again, is the 8mm format, also developed by Sony.)

The two formats are not compatible. You can't take a Beta cassette and use it in a VHS machine. Each has different characteristics. For one thing, the VHS cassette is slightly larger than Beta, making it impossible to load a cassette of one format into a machine of the other. Even if the two cassettes were the same size they'd be incompatible.

The main difference in the systems lies in the number and arrangement of tape track guides in the machine. These track guides are used to keep the tape stretched tightly in the correct position as the tape moves across the rotating drum which carries the record and playback heads of the VCR unit. The guides, along with the tape machine's motors, drive belts and other mechanisms, maintain the torque necessary to keep the tape moving around the head drum at the proper tension.

The VHS system uses nearly twice as many tape guides as does the Beta format. This makes the automatic threading of the VHS machines

slightly more intricate. However, in doing so there tends to be less wear on the tape.

So, which format is better?

The majority of units used by home consumers are of the VHS format. Many stores which are in the business of renting prere-

FIGURE 3–1 In looking for home video equipment, you have a variety of choices.

VHS or Beta? New or Used? **21**

corded movies and other cassette materials to the public handle only VHS for this reason. Simply, there are more VHS machines around than there are Beta. There are also more movie titles available in the VHS format for the same reason. It has been a circle that has built up until Beta has been pushed out of their earlier position of dominance.

There are still many Beta fans. They argue that the initial quality of reproduction seems to be higher with a Beta machine.

When HQ circuitry was invented to improve the VHS imaging, Sony then developed their own improved Beta versions and introduced high fidelity stereo. JVC responded by adding stereo to their systems, and finally came up with Super–VHS stereo, producing 400 lines of resolution.

Beta fans answered that by pointing out the higher cost for the newest format and for the tapes. They also argued that most standard television sets are incapable of displaying the higher resolution anyway. Still, Sony came out with their ED Beta, capable of 500 lines of resolution.

Overall, most servicepeople seem to feel that the VHS format provides a little more stability in the video output. There is less flutter and "flagging" on the screen. However, it is also recognized that the simpler threading and fewer tape guides in the Beta machines make them a little easier to service and to restore to proper working condition in cases of a major malfunction.

Such arguments can go back and forth until someone new to the field doesn't know what to believe. Actually, you needn't be too concerned. Your choice will be based on your own needs.

Friends or family might already have VCRs. If you plan to swap tapes, your format should be the same as theirs. If you have, or are planning to get, a camcorder, once again you'll probably be looking to match the formats.

VHS has the distinct advantage of being more common. You'll have a much broader choice, and usually better prices. This can be especially important if you'll be shopping for a camcorder.

Being more common also means that finding tapes, both blank and prerecorded, will be easier—and again with a broader choice.

Another concern is which machine has the most readily available parts and service in your area. This involves both format and brand. Generally, the makes and models that are most popular in the area will be the ones that have the most parts readily available. This usually means one of the better known brands in the VHS format.

BUYING A VCR

Once you have decided which format is best for your purposes, you are then confronted with literally hundreds of manufacturers of VCR units. There are major companies, such as RCA, Sony, Hitachi, JVC, Panasonic, Zenith, Motorola, and there are the "house brands" of the leading department stores. Although all VCRs are similar, there are differences in control functions, playback/recording speeds, and utility and options available.

The price of the VCR will vary depending on how many options there are. The unit can be as simple, or as complex, as you wish. It's fairly easy to find basic machines on sale for $300 and less. It's even easier to spend $1500 or more.

Many of the things that were once options are now standard equipment. A built–in clock/ timer used to cost extra. Today, you'd have to look very hard to find a VCR that can't be programmed to handle at least 4 shows any time during 2 weeks. The same applies to wireless remote controls. It's difficult to find a new VCR now without a wireless remote.

Programming

Even a basic machine with nothing but standard features will take care of the needs of

just about anyone. Your own needs, however, might be different. For example, you might be using the VCR largely to capture programs while you're away. If so, you might prefer a machine that can be programmed to record 6 or more shows, perhaps over a greater period than two weeks.

Tuner

The tuner section might also be important to you. Most units today are "cable ready," which means that they can directly access all those channels coming in on the cable. Others can do it only with difficulty or with a separate selection box.

Stereo

If you are a fan of video music shows, or simply enjoy better audio quality, consider getting a VCR with stereo capability. Many, if not most, prerecorded videos are stereo. You can still enjoy the new *Star Trek* movie in monaural, but feeding the sound through some good stereo speakers can make it more like an event.

If you don't have a stereo television—or even if you do—you may want to patch the audio output through your home stereo sound system. (See Chapter 4 for more details about hooking the equipment together.)

Some VCRs are also set up to receive and decode MTS stereo broadcasts off the airwaves. This ability is also available in some television sets, or you can get a separate decoding box. If you already have the capability, you may not want to duplicate it in the VCR.

Heads

The standard machine has 2 heads. You can pay a little more and get a machine with more. The 4–head design is one of the most popular. The advantage is in having improved recording/playback, and also a superior "pause" or "still" feature.

Most VCRs have an erase head that is separate from the video record head. The separation between the two is small, but still large enough so that a few inches of tape will have

a new signal going directly on top of one that's already there. The result is a "rainbowing" on the screen, caused by the two signals interfering with one another.

A flying erase (FE) head eliminates this problem. It's mounted on the head assembly, so close to the record head that the tape is wiped clean before the new signal is put on it.

Other Features

Are the controls easy to use in general? Does the unit have the features you want, and do they work the *way* you want them to work?

If possible take the time to learn how the VCR you have in mind operates. One of my own VCRs has the irritating function of backing up whenever "Stop" or "Pause" is pressed, and then backing up a little more again with "Play" or "Record." It's merely irritating during playback, but when it happens in the record mode, some precious seconds can be covered over.

Some VCRs go into record with a single button. Others require that you simultaneously press "play" and "record." You might have a personal liking for one or the other. (The first is more convenient; with the second you're less likely to accidentally record over the top of something you meant to keep.)

While many will carefully look over the features on the VCR before making a purchase, few take this care in looking at the remote. The remote may not be important to you, but don't just pass it by.

The standard remote control is very basic. It can turn the machine on or off, start and stop the play or record, fast forward, rewind, and pause. Most will also allow you to change the channel. That may be enough for you. Or you might prefer a remote control with more features.

The most common is "direct access" of the tuner section. Instead of holding an "up/down" button, you punch in the channel number directly.

If you have plans of enlarging on your system in the future, you'll want a VCR that allows

you to expand and adapt most easily. Of primary consideration in this are the different types of inputs and outputs.

In selecting a VCR, it is worthwhile to consider some other outside factors, and potential future evolutions of the VCR field. There already exist several ways for using a VCR in conjunction with home personal computers. Just as home computers can use a cassette audio tape recorder for the storage of information, so can they use a video tape for the storage of computer information. There are even ways to link the computer and the video recorder for playing interactive games.

One of the best ways to determine the quality of a unit, new or used, is to talk to some people who own at least that brand. Lacking this, spend some time looking through some of the video magazines available. An afternoon at the library looking through both present and back issues is a good investment. Having some familiarity with what is available can save you time, money, and a bad purchase.

BUYING MAIL ORDER

There are hundreds of companies that sell video equipment through the mail. Because of the larger volume and reduced overhead, you can quite often save hundreds of dollars over making the same purchase locally.

There are several disadvantages, however.

1. You'll have to know exactly what you want. Mail order companies rarely, if ever, have the personnel to advise you.
2. You can't put your fingers on the machinery before buying. The responsibility of finding out exactly what you want is entirely up to you.
3. Your purchase is not received immediately. Delivery can take 3–6 weeks.
4. If something is wrong with a mail order unit, all you can do is ship it back, which is both costly and time consuming.
5. If you have a question about operating the

unit, the mail order company is unlikely to have anyone to give you answers.

Normally, you do not have to worry about the honesty of a mail order firm, especially if a company has been around for a while. You can be pretty sure that they will do as promised. Those who advertise in the magazines are often carefully monitored, not just by the government but also by the magazines. The publishers recognize their responsibility to their readers.

One caution is to be aware of the warranty that comes with the product. Many of these companies deal directly with overseas buyers. The product may be warranteed, but only through that overseas source, which is tough for the consumer to enforce. You save on such products, but you take the chance that they will operate through the warranty period. If they malfunction, you could find yourself footing the repair bill.

Getting the "USA Warranty" will usually cost a little more but it means that the American company has inspected the unit and will stand behind it if there is a malfunction during warranty.

The key to buying mail order is knowing what you're doing. It begins with having already done the needed research to determine which brand and model you want, and continues with the recognition of the drawbacks of dealing through the mail.

BUY NEW OR BUY USED?

There are advantages to buying a new machine, not the least of which is the warranty. There is also the satisfaction of pulling the unit out of it's box, and being the first person to use it. Of course, you pay for these things with a higher initial cost.

Buying a used machine can represent a nice bargain or it can bring nothing more than a waste of money. It all depends on how you approach it.

Take a look through the newspaper and you'll find plenty of used machines for sale. The owner could be selling it because something has gone wrong, or the unit might be up for sale because the owner wants more features, a different format, or perhaps he is just tired of it.

Use of this manual can help you to find the bargain and to avoid the lemons. It's possible to find a machine for a very low price that has nothing really wrong with it that a careful cleaning and simple adjustment won't fix. A friend of mine, after reading the original manuscript of this book, found and bought a "junker" for $5. He invested another $20, mostly in materials he'll use to keep his other machines in perfect condition and ended up with a top–of–the–line VCR.

Many users ignore their VCRs until something goes wrong with it. Dust and grime are allowed to build up until the quality of reproduction is severely degraded. The owner assumes it's time to junk it or trade it in, yet nothing is actually wrong with the machine at all. (It's like trading in your new car because it needs a good washing. While few people would do this with cars, it happens all the time with VCRs.)

When buying used equipment, take the same steps you would take in the purchase of a used car. Take the unit for a "test drive," preferably in your own home with your own television set. If at all possible, have a qualified expert check it over. This will cost you a small amount, but it's better than chancing the loss of several hundred dollars.

Like everything else in the world, the simpler the machine, the less likely it is that something will go wrong with it. The more complex the machine, the more things there are to break. On a basic VCR that does nothing but record and playback—one that has no timers, no remote control, etc.—the maintenance is comparably easier. Quite often, many of the options can be added by using external devices. (For example, you can get a basic machine to turn itself on and off to record a program by using an external timer.)

Newer units have gone almost exclusively electronic. Older units, however, used more mechanical controls, back to the first which even have mechanical rotary channel selectors. The main problem with mechanical controls is that they are prone to mechanical troubles. That statement isn't as trite (or as redundant) as it might sound. A mechanical switch can fail both electrically and mechanically. It's lifespan is generally much shorter than an electronic switch. Sections such as electronic tuners also tend to be more stable than the earlier, more mechanical versions.

Sometimes you can "dress" the part and get it to function again. If the problem is corroded contacts, for example, you might be able to clean them well enough to get the component to function again. Other times, the job won't be so easy and may be impossible. At those times you face a potentially serious problem of finding a suitable replacement part.

In general, the more mechanical the unit, the older it is, which in turn means you'll probably have more trouble restoring it and a *lot* more trouble finding parts.

OTHER VHS AND BETA EQUIPMENT

Chapters 11 and 12 are devoted to the various other pieces of home video equipment. There are many peripherals available—cameras, switching devices, editing machines, etc. All these make it possible for you to create your own video programs. Much of this is centered around the camcorder, which is a portable VCR and video camera in one package.

Video Tape

Video tape is swiftly replacing movie film for home entertainment. The initial investment in portable video equipment is a little higher than a comparable 8 millimeter sound movie setup, but film processing is expensive. After you've paid for the film and developing, you'll

have spent about $7 (or more) and a day or two waiting for *3 minutes* of film. The same $7 will buy a video cassette that can store up to *6 hours* of recorded fun and be viewed instantly. An extra plus is that if a particular tape doesn't come out the way you want it, you can record on it again.

VHS-C is a miniaturized version of VHS. With an adaptor, you can play one of these smaller cartridges in the home VHS deck. 8mm is a format all onto itself. Even the way the cassettes and the tape inside are made is completely different.

Camcorders

As with VCRs, the most popular format for the camcorder is VHS. You can also find Beta format camcorders, which might be the best choice if your primary equipment is Beta. Home video cameras also offer two additional format choices—VHS-C and 8mm. The advantage of both is smaller size, making the camcorder lighter and easier to carry; but disadvantage is that it is harder to hold steady.

Cables

Regardless of the format of the camcorder, it can be "patched" into the home unit with cables. The same is true of transferring any format to another (dubbing). Attach the two machines together and re-record. The problem with this is that you always end up with at least second-generation video and some loss of signal in making a copy.

Other Peripherals

There are peripherals with which you can boost the signal to reduce loss in dubbing and others which allow you to add fades, titles and other special effects. There are "copy protection busters," rewinders, and more kinds of switches, signal splitters and cables than need to be covered. Usually there is no need to buy this equipment when you buy your VCR. Except with used equipment, you'll probably get at least the basics as a part of the package you buy. You can buy other equipment later, as the need arises. (See also Chapters 11 and 12 for more details.)

SUMMARY

There are two basic formats available, VHS and Beta. Both have advantages and disadvantages, but either will do a good job for you. There are the "full-sized" formats, such as Super-VHS, designed to produce superior results and the miniature formats of VHS-C and 8mm, both of which reduce the size and weight of camcorders.

VHS tends to be easier on the tapes, which both helps to increase the lifespan of the tapes and to increase stability over a longer period of time. The VHS format machines are also more common, which makes purchase or rental of prerecorded material easier.

Beta machines produce a sharper image initially. The tape transport mechanism is less complex than that of a VHS machine, making repairs and maintenance easier and generally less expensive.

You can now find 8mm home VCR decks, and can buy adaptors that allow you to play VHS-C in a home VHS deck.

You cannot use a Beta cassette in a VHS machine, or vice versa. However, you *can* dub from one format to the other simply by using cables to connect the two machines together. When doing this, keep in mind that some kinds of dubbing is copyright infringement and a serious offense.

Buying new will give you a warranty and a better chance of getting exactly which features you want. Buying used saves you money, but requires that you exercise a little extra caution and thought prior to the purchase. You don't want to end up with someone else's headaches. Chances are good that you can put a malfunctioning machine back into working order, but you should recognize your limitations. It doesn't make much sense to buy a used machine to save $150 and then spend $250 to have a technician put it into shape.

Chapter 4

How a VCR Works

Trying to diagnose, repair, or even maintain a piece of equipment without understanding at least the basics of its operation is difficult. On the other hand, if you have a grasp of how something is supposed to work, the job of troubleshooting is much easier, as are the tasks of repair and maintenance.

Your VCR might seem to be too complicated for you to handle. This is why so many people shy away from attempting to perform even the basics. Yet, once you understand the principles of how a VCR operates, you'll find that you *can* handle not just ordinary maintenance but also most of the malfunctions that occur.

The principles of operation are fairly easy to understand. The signals are recorded and played back via electromagnetism in much the same way as a standard audio machine. The tape path is more complex because the video signal is more complex. But, you don't need to know how to design a VCR. You don't need to be an electronics engineer. You don't even have to have a technical background.

THE VIDEO CAMERA

Light picked up by the camera is converted into electrical pulses which can then be pro-cessed and recorded. The scene being captured is "seen" as tiny dots. These are actually light sensitive spots on the camera's pickup.

An easy way to envision how this works is to think of a standard photocell. As light falls on this, electricity is generated. Now imagine thousands of these cells all mounted on a single surface, and with the reflected light being focused on them by a lens.

The darker portions of the original image reflect less light and the cells affected produce less electricity. Likewise, the brighter portions of the image reflect more light, which in turn causes the respective cells to generate more electricity. (It's more complex than this, especially when colors are involved. Still, it should give you a basic idea of how it works.)

A scene to be taped or televised is scanned by the video camera. Essentially, this operation is much like the operation of your eye when you read a book. The eye begins at the upper left–hand corner of the page, reads the first word, and moves across the line to the last word. Then the eye instantly flicks back to the left edge of the second line and again moves horizontally across the page. The process is repeated from top to bottom on the page. Just as the human eye reads a page, the electronic camera "reads" an image.

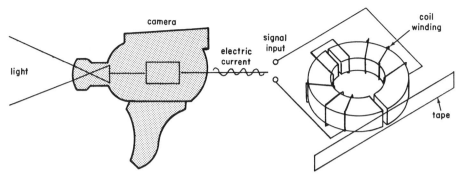

FIGURE 4–1 How a visual image is picked up.

When the electronic circuits in a video camera scan an image, a light–sensitive "eye" moves across the scene from upper left to upper right. As this horizontal path is traced, the variance in brightness, or light level, is converted by the moving electronic "eye" into a voltage which varies exactly in step with the intensity of the light. (A bright color produces a certain voltage level, while darker colors and dense black produce correspondingly different voltages.) When the "eye" reaches the lower right-hand corner of the scene, it "blinks" for a fraction of an instant while it is moved back to the left corner of the scene and slightly downward so it may then trace a second horizontal scan just below that first trace.

While it may take your eye a minute or two to read a complete page, this electrical scanning by the camera is almost instantaneous. A standard television picture is reproduced by tracing horizontal lines of varying light level from the top to the bottom of the scene. These lines are scanned from left to right, top to bottom, sixty times each second.

At this speed, the human eye simply cannot discern the individual lines as they are being traced ("written") across and down the screen. Instead of flickering light, we "see" a reproduction of the original scene as the varying voltages are painted back on our TV screens in the form of changing light levels.

TRANSMISSION AND RECEPTION

Audio and video signals can be transmitted to the VCR in several ways. One is to transmit the signals over the air waves. Another is to send the signals through a cable.

When you receive a signal from a local television station, for example, the antenna on your end is picking up a transmission over the air waves from the station's transmitting antennas. This method can be degraded by various kinds of interference (storms, stronger signals, etc.) and by distance. Cable companies, however, send the signals along wires. Assuming that the system is properly constructed and the signals are amplified to keep the strength constant, the signal you get in your home is generally superior to that you'd get over the air waves.

Similarly the VCR is connected to other devices via cables. This holds true for the inputs (i.e., camera, microphone, other VCRs) and the outputs (TV, other VCRs). Because these cables are usually short, the signal isn't degraded at all. Even then, and especially if the distance is longer, the use of better quality cable and connectors can further reduce signal losses.

Via cable or antenna, the signal is received and then processed by the circuits inside the VCR and/or television. With the television, those

signals are simply changed back into the sounds and visual images. The VCR, on the other hand, does one of two things: it either captures those signals by changing them to electronic pulses to drive the electromagnets to impress magnetic fields onto a tape; or it converts the impressed fields into electronic pulses to drive the television set.

RECORDING WITH ELECTROMAGNETISM

One of the great entertainment advances of the modern world has involved improved techniques for recording sound and moving pictures. First came genius Thomas Edison's famed "talking machine," through which sound recordings were made on wire cylinders. Things soon progressed to wax cylinders and then to plastic disks. Eventually audio tape was developed.

Over the years, camerawork similarly advanced from the still camera which used massive metal and glass plates requiring deadly chemicals, to roll film, to flickering motion pictures, and then finally to modern technology where moving images may also be permanently stored on magnetic tape. Combine the audio and video recording, and you have, essentially, your VCR.

Audio

An electronic recording device involves one technique or another for converting sound waves into pulses of electrical energy. The pulses are then stored. Playback is merely doing things the other way around—taking the stored signals, converting them into electrical pulses and those back to signals as close as possible to the original.

The record on a turntable does this conversion via the grooves. On the recording end, sound has caused a vibration. This is used to move a needle so that the vibration is impressed into the plastic of the recording disk. Later, as the playback needle moves, it is vibrated in grooves. This vibration is converted back into electricity which drives a magnet to cause the cone of a speaker to vibrate. You have a sound quite similar to the original.

An audio tape recorder does the same job but uses stored magnetic fields. The tape is coated with billions of tiny particles capable of taking and holding magnetism. The incoming signal causes an electromagnet to impress magnetic fields in specific patterns onto the tape. In playback, those stored magnetic patterns are "read" by the electromagnet and turned back into a signal identical (almost) to the original.

Video

Audio is relatively simple in comparison to video. The range of frequencies needed is smaller. Accurate capture and replay of a sound can be done with tape moving less than an inch per second. Higher speeds make greater accuracy possible, but the highest speeds used are still rated in inches per second. Because of the greater complexity of a visual image, accomplishing the same for video requires an effective tape speed rated in feet per second.

The first videotape recorders were huge and tremendously expensive. They were the exclusive property of highly profitable television stations. The initial prototype video recorders

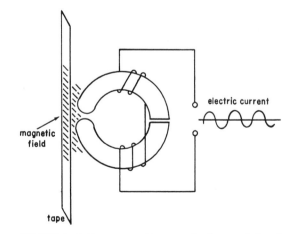

FIGURE 4-2 How a sound is magnetically recorded and reproduced.

made available in the 1950s cost in excess of $100,000 each. They were reel–to–reel devices, with plastic-based video tape that rolled from one reel, across a recording or playback heads, and transferred to the pickup reel. To be able to handle all of the electrical impulses involved in storing the sound and video images, the early tape was two–inches wide, and was moved across the heads at high speed.

Those first VTRs had stationary heads, just as audio recorders do. This meant that the tape had to be dragged across the heads at a very rapid rate. A large reel of tape could hold only minutes of recording. Stresses on the tape, and on the machinery in general, were very large. Just pressing *Stop* at the required transport speed was enough to cause a variety of problems.

The reel–to–reel stayed around. By the 1960s enough advances were made to make it possible for the average person to own one. The problem was that a simple black & white machine cost in the $6000+ range. They also had the unfortunate tendency to break down, and there weren't many technicians around who could repair the units.

Speed, however, is relative. You can move the tape across the heads, or you can move the heads across the tape. From this simple truth came the combination of movement of both the tape and the heads to create a much higher relative speed.

The tape in your VCR is moved forward at a slow, more manageable speed. The differ-

ence is made up for by moving the heads—not linearly but spinning (at 1800 RPM). By tilting the head assembly, a helical path is created. The recording can then be impressed in stripes, effectively increasing the "length" of the tape. (24 half–inch stripes, taking up just a fraction of an inch, are the equivalent of a linear foot.)

This makes it possible to squeeze as much as 6 hours of quality recording onto the tape of a single compact cassette.

Cassettes

A great improvement in the convenience of recorders came with the advent of audio tape cassettes. These are like miniature versions of reel–to–reel, but with the two reels constantly attached and safely enclosed. With the development of helical path recording, the same became possible with video.

A video cassette is somewhat similar to an audio cassette. Both eliminate the need for tedious threading of the tape through the machine. Both protect the tape, which is nestled inside the casing. Dust and other contaminants can't get at it easily. Your fingers never (or shouldn't) touch the tape itself. This is true of both audio and video. (See Chapter 6 for more on cassettes.)

The first home VCRs were bulky and expensive. Many improvements have been made. Various circuitry, new tape manufacturing techniques, and so on have brought video recording to a point that VCRs are reliable. Because of the relative low prices, VCRs have become almost as common as television sets. (Those, too, are undergoing a new series of design improvements, brought about largely by advances made in video tape technology.)

TAPE LOADING AND PATH

The cassette design requires some special things to happen. The tape has to be drawn from the cassette, fed through the transport mechanism and get taken up on the opposite

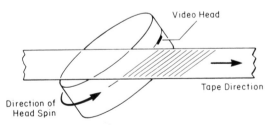

FIGURE 4–3 The tape moves across the head at a few inches per second; the head spins at 1800 rpm, creating a very high relative speed. The head assembly tilt creates the helical path, which greatly increases the 'length' of the tape available to store the magnetic fields.

spool—all automatically, without your touching the tape. When a cassette is placed into the player and "Play" or "Record" is activated, you should be able to just sit back and enjoy.

Top loading machines have all but disappeared. These allowed the cassette to be inserted and then pushed down into the VCR. Nothing else happened until the tape was to be put into use.

The more popular front loading machines have a sensor which recognizes that a tape is being inserted. The cassette is grabbed, pulled inside (with a spring-loaded door coming down behind it to seal out dust) and set onto the platform.

Either way, a pin releases a catch on the protective door of the cassette. This door is lifted out of the way so that the tape can be pulled out of the cassette. Another pin releases a catch for the reels. With power applied, and "Play" or "Record" activated, several motors begin spinning. One or more capstans (round metal dowels) are driven by a motor. Motors, or a combination of motor and belts, drive the supply and takeup spools. The main video head also begins spinning.

A rubber pressure roller (pinch roller) is mechanically pushed into position, pressing the tape firmly between itself and the spinning capstan. The tape is literally squeezed between the capstan and pressure roller. It is then pulled

from the supply reel and fed through a series of tape guides which bring the tape across the record/playback heads.

There are generally at least four heads. First comes the erase head. This is activated only in the "record" mode. It provides an unpatterned magnetic field, the function of which is to erase anything that might be on the tape, making it possible to record on top of an existing recording without bringing on interference.

The video heads are on the drum–like assembly. As mentioned earlier, this drums spins at 1800 rpm. It's tilted at an angle so that the heads make diagonal stripes as the tape is drawn across.

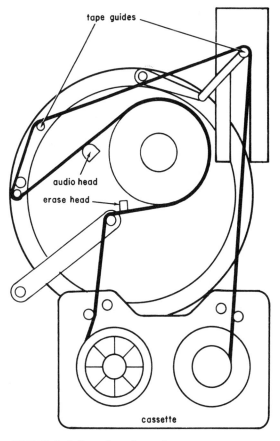

FIGURE 4–5 Tape threading path.

FIGURE 4–4 The loading mechanism.

This complicated operation is done automatically. All you have to do is to press a button. Press "Stop" or "Eject" and the whole process "undoes" itself. For obvious reasons, the machine has to be in good operating condition.

TRACKS AND TRACKING

Look again at Fig. 4–3. You'll notice the cue track (also called a sync track) on one edge of the tape. This linear recording carries all the information the equipment needs to operate. It is responsible for keeping everything "in step" with everything else. This begins with the original recording device and ends with your television set.

Without this track, nothing will function. If it has been damaged even slightly, the recording won't playback properly. If you rent or play a tape and see an image that is hopping, you'll probably find that the cue track has been damaged in some way. This is a sign that the machine that played the tape is out of alignment; the tape is probably being crushed against one or more of the guides.

The information contained on this track is put there during the recording. It tells the VCR how to read the recording and the speed at which the recording was made. The signals also synchronize the television set, telling it how to "paint the pictures" on the screen.

THE TELEVISION

In audio, the speaker is the operational opposite of a microphone. For video the opposite of the camera is the television monitor. (Your television set is a combination of both audio and video.)

The microphone picks up the vibrations of the sound waves and converts them into electrical pulses which can then be recorded. The camera picks up light, converts this into electrical pulses, which is similarly recorded.

In playback, those stored magnetic patterns are turned back into electricity. For the audio, that eventually drives the speaker cone, which vibrates the air and you have sound once again. For the video portion, the pulses cause the electron guns of the monitor to "paint the picture" on the screen. As with the camera pickup, the screen is covered from the upper left to the lower right sixty times per second.

Light sensitive phosphors on the picture tube are excited by the electrons, give off light . . . and you have a picture. This is oversimplified, of course. There are different circuits to handle each of the primary electronic colors (red, green, and blue) plus luminance (brightness) and chrominance (overall color brightness), contrast, sharpness, and so on.

SUMMARY

The original scene is scanned by a camera. A camera used for film has the image recorded by allowing the light to cause a chemical change in the film. The video camera scans the scene electronically, measuring and recording differences in brightness and tone. Meanwhile, the microphone takes the fluctuations caused by sound waves and converts them to an electrical signal that varies with the original sound.

Both signals are fed to the recording heads. The changes in voltage going to the heads cause a change in the magnetic field. This pattern is stored on the tape by charging the tiny magnetic particles that coat the tape. Later this same pattern of charge can be picked up by the playback heads and converted back into an electrical pattern that exactly matches that of the original scene.

These variations in voltage can be sent down a cable, or through the air to your television antenna. However they are transmitted to your home, the principle is the same. So is the principle behind making your own recordings. The incoming signal causes a voltage change on the heads, which creates a pattern of magnetism on the tape.

An audio tape moves in a straight line across the heads. This is all that is needed since the audio signal itself is less complex than a video signal. A video tape records the video image on diagonal tracks. The needed speed for a complete and accurate scan is provided partially by the actual movement of the tape, but primarily by the head spinning (at 1800 rpm).

Loading of the VCR cassette is handled automatically, either when you insert the cassette or when you push the "Play" button on the unit. Capstans, pinch rollers and pins pull the tape from the cassette, run it through tape guides and wrap it around the heads.

The heads then "read" the magnetic signals stored in the particles—and you have a beautiful reproduction.

Chapter 5

Making Proper Input/Output Connections

One of the very first things the owner of a new VCR should do is to become familiar with the various inputs and outputs of the machine, and then the inputs and outputs of anything to which it will be connected. Most equipment is fairly standard, as are the connectors.

Hooking up your VCR is generally easy and straightforward. Run a cable from the VCR's output to the input of the television and press "Play." For recording, connect the signal source (antenna, cable, etc.) to the input of the VCR and press "Record."

Other times, making the connections may not be so simple. For example, you might want to drive two television sets with the same VCR; or you might want both a local antenna and a satellite dish to feed the VCR's inputs; or maybe you want all of that.

Your design might even require that you make you own cables (such as a cable to run to a remote TV).

Whatever you system entails, chances are very good that you can design and build it, even if it is complex.

THE BASIC INPUTS AND OUTPUTS

With most VCRs now, all the inputs and outputs are located in the back. A few models have some jacks in the front. Even with these, most of your connections will be made on the rear panel of the VCR.

The two major types of connectors are phono jacks and the radio frequency (RF–threaded) jack. The first is used most commonly when the video and audio signals are separate. The second generally carries a composite signal of both. The number and types of connectors depends on which machine you own and what capabilities it has.

All VCRs will have connectors to utilize composite input and output signals. They use RF connectors and shielded cable. (See Fig. 5–4). The composite input is used most often to bring in signals from the antenna or other signal source, with the output used to bring the signal from the VCR to the television set.

The separate video and audio inputs and outputs are used to connect two VCRs, for ex-

34

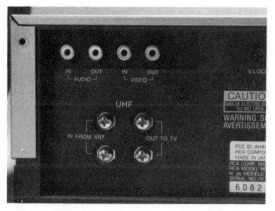

FIGURE 5-1 Inputs and outputs on the rear panel.

ample. This is accomplished with phono jacks (See Fig. 5-2.) The audio output can also be connected to your home stereo system. Likewise, the audio input can be connected to a microphone or audio mixer.

A VCR capable of stereo will have dual jacks (for left and right channels) for audio input and output.

A few VCRs may have a DIN jack, which uses a multi-pin socket/plug and an appropriate multi-wire cable. This same kind of jack can be found on machines such as the Super-VHS, where it carries the additional signals for chrominance (color) and luminance (color brightness).

THE BASIC CABLES AND CONNECTORS

As few as one and sometimes as many as four or more adaptors and connector cables are supplied with the VCR when you buy it. This

FIGURE 5-2 Some models also have jacks in the front.

FIGURE 5-3 Cables that come with a new VCR.

is sufficient for the standard VCR-to-TV hookup. The number of connectors you will need for your own hookup depends on what you have in mind.

The standard is a length of 75-ohm coaxial cable with RF connectors on the ends. This is to connect the VCR to one television set. Most of the time you will also get 75-ohm to 300-ohm matching transformer to convert the 75-ohm impedance of the VCR and cable to a television set that requires a 300-ohm impedance (twin-wire) input.

Note: The ohm is a unit of impedance measurement. A 75-ohm cable offers 75-ohms of impedance to the flow of current along its length. This impedance will be 75 ohms no matter how long the cable is. The same is true of the 300-ohm twin-lead television antenna wire. It is necessary to match impedances when connecting audio and video devices to each other. Improper matches will result in poor quality, or in no transfer of signal at all. As an example, you cannot directly connect the 75-ohm ouput of your VCR to a 300-ohm input on a television set. This mismatch will cause a loss of signal

FIGURE 5-4 75-ohm RF cable and 300-ohm twin-lead.

Making Proper Input/Output Connections **35**

strength. The picture will be snowy and will lose detail. It may not be there at all. A transformer which converts impedances from 75–ohms to 300-ohms must be used between the devices.

You will probably also get a 300–ohm to 75–ohm matching transformer. This does just the opposite of the adaptor just mentioned. It allows you to hook a 300–ohm twin–lead television antenna wire to the 75–ohm VCR input.

The most common adaptor has a pair of screw-lugs on the 300-ohm side and a male RF connector on the other. The reason this is possible is because the transformer doesn't care in which direction it works. One side will input/output at a 300-ohm impedance; the other will input/output at a 75-ohm impedance.

To go from the VCR (75–ohm) to the 300–ohm connector on the television set, the transformer plugs into the composite output on the VCR. A length of the flat 300–ohm twin-lead television antenna wire (usually supplied with the unit) is used to carry the signal to the television set.

A second type of matching transformer has a female RF connector on one side (to accept the cable) and a short piece of twin-lead with spade lugs on the other (to hook to the screw–lugs on the television set). If you have one of these, you'd run a standard 75–ohm RF cable from the VCR to the transformer, and connect the 300–ohm transformer leads to the television set.

Check your VCR and television carefully to see which type of connectors and cables are needed. This becomes important if your set-up is to be more complex than just VCR–to–TV. In any case, it's a good idea to have some cables with the needed connectors on hand.

For standard lengths, it is possible to purchase the cables premade either at the store where you bought your VCR or at any electronics supply store, such as Radio Shack, or in the electronics department of most major department stores.

MAKING CABLES

If you have a need for longer cables, or just to save a bit of money, you can quite easily make your own custom cables. In most cases this requires a minimum of tools and skill.

The key is to use the correct cable with the correct connector to handle the correct job. A little caution is needed here because some cables *look* much the same but aren't. The best example is the standard RG–59/U cable used for the composite signals. This has the 75–ohm impedance needed. Very similar in appearance is RG–58/U. This cable is used in communications, such as ham radio, and has an impedance of 50 ohms. The two *look* the same, but are not interchangeable.

Try to find the best quality cables/wires and connectors possible. The slight extra cost is worth it! The better made products have better characteristics, which translates to mean that you won't suffer as much signal loss. This becomes especially important if the cable run is to be long.

What tools you need depends on the type of cable you are making. To make up a length of cable with RG–59/U and RF connectors, all you'll really need is the cable, some wire cut-

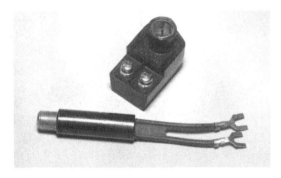

FIGURE 5–5 The two types of matching transformers.

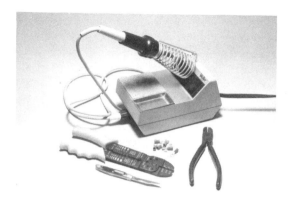

FIGURE 5–6 Tools for making cables: wire cutters, a sharp knife, various connectors and lugs, crimping tool, soldering iron.

FIGURE 5–7 Close up of RF connector.

ters, solderless RF connectors for the ends and a crimping tool. (You can get by using a pliers, but the crimping tool does a better cleaner job.)

For other cables requiring lugs, such as the 300-ohm twin-lead, you may also need an insulation stripper and a soldering iron (with resin-core solder).

RF Cable and Connectors

The 75–ohm RG–59/U cable is the most used form of connecting inputs (antenna, cable, etc.) to the VCR and the VCR with televisions. The cable consists of a hard outer rubber sheath, a braided lattice that serves as a shield/ground, some type of foam insulator, and a solid wire in the center to carry the signal. It is efficient, has relatively little signal loss, and is shielded.

The standard male RF connector consists of a threaded (usually) ring with a sleeve and a hole in the middle. The sleeve makes contact with the lattice ground. The hole allows the center wire and a small amount of insulator. The wire then becomes the male "prong" that slides into the female RF connector.

The easiest connector to install is the solderless type just described. A special tool is available that will slice through the outer rubber, the shield, and insulator while not touching the inner conductor. If you'll be making a lot of cables, consider purchasing this tool.

Lacking this, a sharp knife can be used, but *only* if you're very careful! There is an immediate and obvious danger to you just from the blade. There is also a danger to the cable. If you nick the center conductor, you'll have to clip off that mistake and begin again.

To make the solderless RF cabling:

1. Cut through to the center wire—WITHOUT CUTTING OR EVEN TOUCHING IT!—so that approximately 1/4" is exposed. If in doubt, expose more of this conductor rather than less. (You can always trim it later with a wire cutters.)
2. Slide the retaining ring (if the connector has a separate one) over the cable. Then carefully push the connector into place so that the sleeve slides under the outer covering.

FIGURE 5–8 Carefully remove the outer parts, leaving only the center conductor.

Making Proper Input/Output Connections **37**

FIGURE 5–9 Slide the crimping ring (if there is one) over the cable, and push the connector into place.

3. Crimp the ring to be sure that everything is tight.
4. Trim the center conductor if necessary . . . and you're done!

It's a good idea to make the length of the cable at least 10% longer than you think you'll need. This allows you some leeway for errors. However, if you want to make a cable the *exact*

length needed (within a few inches, anyway), and especially if the routing will go through holes or is to be fished through existing walls, install a connector on one end only. With the connector at one side of the route, run the cable to the far end and *then* install the other connector.

300–Ohm Twin–Lead and Spade Lugs

RF cabling has all but replaced the older 300–ohm twin–lead antenna wire. The cable is more efficient, has fewer losses, and is shielded. In addition, it isn't affected by bends and twists the way twin–lead is. Even so, you may find yourself having to make a length of 300–ohm wiring.

Although it's possible to twist the stranded wires together, this makes for an unclean and very possibly troublesome connection. Much better is to take a few minutes to install spade lugs at the ends.

A spade lug is a U–shaped connector which is designed to be slipped under the head of a screw to be firmly attached to a terminal. The other end of the lug is either a small cylinder or fold-over leafs designed to wrap around a section of wire.

FIGURE 5–10 Crimp the ring.

FIGURE 5–11 Spade lugs.

FIGURE 5–12 Remove a piece of the center.

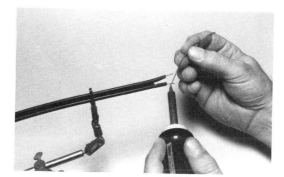

FIGURE 5–14 'Tin' the twisted wires.

To prepare a 300-ohm twin-lead connector:

1. Carefully use a sharp knife to remove 2–3 inches of the center material. Just as carefully, remove about 1/2 inch of the insulation from each of the two wires. Be very careful not to cut or nick any of the strands. (Note: Some spade lugs require more or less wire to be exposed. How much of the insulation you remove is determined by the lug to be used.)
2. Examine the bared wire carefully. If it's corroded and/or dull, clip off a few inches and try again. It's important that the wire you use is clean and shiny.

3. Twist the wire strands together and use your soldering iron to pre-tin (apply a *small* amount of solder) the ends.
4. Attach the spade lug to the wire by either pushing the wire through the cylindrical end of the lug or by laying the wire between the wrap around leafs of the lugs and squeezing the leafs in and around the wire. Either way, be sure that no wire is exposed beyond the lug on either side. If it does, you may have to trim the end of the bare wire slightly to get a perfect, professional fit.
5. Crimp the holding metal of the lug tightly to the wire.
6. Apply the tip of your soldering iron to this connection and apply enough solder to make

FIGURE 5–13 Strip the ends so that about 1/2″ of bare wire is exposed, then twist the wires.

FIGURE 5–15 Push the tinned wire into the lug.

Making Proper Input/Output Connections **39**

a firm electrical connection. (Don't just blob on the solder.)

A Note on Soldering: When soldering, heat the wire (in tinning) or joint. Never just melt the solder and let it drip.

Phono Plugs

When audio and video are carried separately, such as in the typical VCR-to-VCR or VCR-to-stereo hookups, the connectors used are almost invariably phono plugs. It gets its name because it has been used to hookup phonographs for a very long time.

The standard phono plug is 1/4–inch in diameter, with a relatively large center prong and "wings" around the rim. The cabling between is somewhat similar to that of RF cabling in that it has an outer covering, a latticed ground/shield, a layer of insulation, and a center conductor (almost always stranded).

Unfortunately, many of the "stock" cables with phono plug ends are made from inexpensive and poorly shielded cable. This gives you one more reason to take the effort to find quality cabling.

Making these cables properly means that you have to solder. Even if the sleeve will slide under the outer braided conductor, the center prong is large enough that the center conductor wires won't fill it to make a firm contact. This makes building such a cable a little more tricky. How you proceed also depends on the kind of connector you are using. Some require that you separate the braiding from the center conductor in steps. Others rely on pushing a sleeve into the ground braiding and soldering only the center conductor.

However you do it, the goal is to be sure that the center conductor of the cable is firmly attached, physically and electrically, to the center prong; that the ground/shield braiding is firmly attached to the "wings" of the connector; that both are insulated from the other; and that the whole thing will hold together when pushed or pulled.

For the most complicated version:

1. Slide the outer case over the cable and cut away about an inch of just the outer insulation. (How much you need to remove depends on the particular connector.)
2. Using a point of some kind—a scribe or the tip of a pencil—unravel the lattice, pull it back, and twist the wires together.
3. Remove the insulation to expose the center strands. Be sure that there is enough insulation to keep the two sets of wires separate.
4. Twist the strands together and "tin" both sets of wires.

FIGURE 5–16 Phono plug.

FIGURE 5–17 Strip off the outer insulation.

FIGURE 5–18 Unbraid the lattice, pull it to the side and twist it together.

5. Insert the center wire into the prong and the outer braid into (or onto) the outer part of the connector.
6. Solder them in place to make a physically and electrically strong joint.

The soldering must be done carefully. Heat the metal of the connector—don't just melt the solder and let it drip. That might hold for a while, but the joint will not be secure (physically or electrically).

FIGURE 5–19 Strip off the inner insulation and twist the strands together.

FIGURE 5–20 Tin the wires.

Other Cables and Connectors

At times you may find yourself in need of something other than the three standards above. The number of possibilities is nearly endless, but the same general rules apply.

- Always try to get the best materials.
- When applicable, pay attention to impedance matching.
- Be sure that the connectors and cables/wires are the right ones for the job.
- Do any cutting or stripping very carefully, both for your own safety and to keep from nicking any of the wires.
- Inspect the bared wire to be sure that it's clean and shiny. If there is any dullness, snip off a few inches and try again.

FIGURE 5–21 Solder the center wires to the center prong; and the braid to the outer portion.

- Remember that each connection has to be secure, both physically and electrically. If soldering is required, heat the wire or joint and let *that* rather than the tip of the soldering iron melt the solder.

Go step–by–step carefully and you'll find that you can build just about any cable, no matter how complex.

TESTING THE CABLE

After you've made a cable or when you need to troubleshoot a cable you suspect of giving problems, get out your VOM and test it. This is much preferable to testing a new cable by using it. If there is a short, damage to the equipment can result.

There are two simple tests—one for continuity and one for shorts. *Continuity* simply means that the wire continues unbroken. If there is a break in the wire, current cannot flow and there is no circuit. A *short* means that two wires are touching that should not be, which in turn causes the current to go where it's not supposed to go.

Set your VOM to read resistance. The range used isn't critical. Test the meter by touching its two probes together. The meter should deflect full scale to show zero resistance.

To test for continuity touch one probe to one end of a wire and the other probe to the opposite end of the same wire. This can be done by touching the wire directly (such as with an RF cable), by touching the pin or socket that holds the wire, or by touching the lug to which it is soldered. If the wire is continuous, the meter will deflect all the way across the scale to show zero (or very close to it) resistance. If the wire shows a high resistance, something is wrong along the wire. If the meter shows infinite resistance, there is a break.

Repeat the test for each wire in the cable. That is, test the center conductor, then test the outer ground. With a multiwire cable, test each one in turn.

If you suspect that the problem might be intermittent (and even if you don't), wiggle the connector while the probes are in place. If the meter reading changes, something is loose.

To test for a short, touch one probe to the center conductor and the other probe to the outer ring. You should get a reading of infinite resistance, which means that no current is passing. If current does pass, the two are touching somewhere.

FIGURE 5–22 Testing the cable for continuity.

FIGURE 5–23 Testing for a short.

As with continuity, test each wire; also try wiggling the connector while it is being tested.

MAKING THE CONNECTION

The most basic kind of connection is to run the incoming signal from the antenna (or cable system) to the VCR and then hook the VCR to the television. You would now use the VCR/TV switch. In the "VCR" position, its own signal is being fed to the television set. You can either use the VCR's tuner or play a tape. In the "TV" position, or if the VCR is off, the incoming signal passes straight to the television. You can now record off the air, record one channel while watching another, and play tapes back.

Everything else is basically a modification of this scheme. Just how you do it depends on what you're trying to do. The key is to keep things as simple as possible. You *could* complicate the above connection by splitting the incoming antenna cable, feeding the VCR and television independently, then "unsplitting" so that the television has two cables (one from the antenna and one from the VCR) coming in; but there is no reason to do so. It only means extra work, extra expense—and extra trouble! For all this effort you end up getting interference.

OUTPUT SELECTOR

Before you make even the most basic connection, you must first set the VCR to output on a particular television channel. In the play-back mode, the VCR output is fed to the TV set on one specific channel—either channel 3 or 4. (A few will allow channel 2.) The selection is usually made with a small switch on the back of the VCR. (The instruction manual that came with the VCR will show you how to find the switch.) The idea behind this is to give the VCR a "blank" channel to eliminate interference.

For example, if your area has a strong channel 3 but no channel 4, you'd set the switch

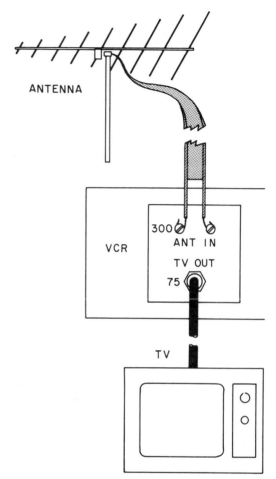

FIGURE 5-24 The simplest connection feeds the signal from the antenna to the VCR, with the VCR feeding the TV.

on the VCR to output on channel 4. If it's on channel 3, the VCR's signal is trying to "compete" with the local broadcast. Even though the VCR's signal is stronger, the local station might be strong enough to cause an irritating interference. Set to channel 4, the VCR would have the channel all to itself.

All you have to do is determine which channel is empty in your area. In rare instances when there are stations broadcasting on both channels 3 and 4, have your VCR set to feed on the channel of the *weaker* (farthest away)

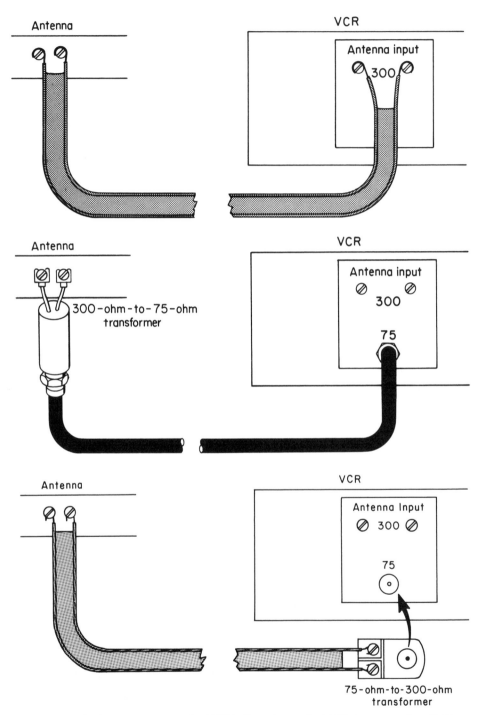

FIGURE 5–25 The three basic ways to connect the VCR to the antenna. **A**. A 300-ohm connection. **B**. Use a matching transformer at the antenna so that a 75-ohm cable can be used. **C**. Use a matching transformer at the VCR.

of the two. You can also ask the dealer which of the two has proved to be best in your area.

ANTENNA HOOKUPS

How good an antenna you need depends on your location and the quality of the local broadcasting transmitters. A simple pair of "rabbit ears" might be sufficient or you might need a large array capable of picking distant and weak signals.

It's generally not a good idea to try using rabbit ears to feed your VCR. These inside antennas must be turned for best reception each time you change channels. If you have the rabbit ears properly set to record channel 10, the signal you receive on channel 12 may be too poor for viewing or recording. Also, the quality of reception can change drastically anytime someone moves around the room (the human body can greatly affect video frequency waves on their way to the rabbit ears).

It's best to have an outside antenna, a cable system, or a satellite receiver (if your home is equipped with one) feeding the VCR. This ensures the best possible signal for your recordings.

Overall, the better the antenna, the better your signal. That doesn't mean you should run down to buy the ULTIMAXO SUPER capable of grabbing a signal from a 5000 watt transmitter at a distance of 250 miles when you live 10 miles from a 100,000 watt transmitter.

If you already have an antenna, you know what kind of job it's doing for you. You'll know if you need a newer and/or better one. Even if it seems adequate, inspect all of the cables, wires, and connectors used to connect the antenna to the various TV sets in the home and to your VCR. They should be in good condition. If any show signs of wear or fraying, replace them—or expect to have a poor signal.

Most television antennas have lugs for a 300-ohm twin-lead wire. This is largely because of the inherent impedance of the design, but is also a holdover from earlier days.

Although you *can* connect everything using the 300-ohm twin-lead antenna wire, there are some distinct disadvantages of doing so. The two wires are run side by side. Because there is no shielding, the wires are more prone to interference from outside sources. (The insulation is *not* a shielding.) The lacking of shielding also means that stand-off insulators are needed to keep the wires from touching the house. In addition, care must be taken so that the wire doesn't have any sharp bends in it. Finally, the length must be exact; coiling any excess wire can cause a poor signal. If your present system is set up this way, consider taking the time to "modernize."

The 75-ohm coaxial cable doesn't have any of these problems. The outer braiding serves as a ground and as a shield. Any interference is shunted to ground before it reaches the center conductor which carries the signal. You can run the cable right alongside electrical and telephone wires and other metal objects that cause interference when the 300-ohm antenna wire was used.

Conversion is not difficult. All you need is a 300-to-75 ohm matching transformer at the antenna, and the cable to bring the signal inside. (Because you know how to make your own cable, the cost is fairly small.)

VHF/UHF

Sometimes the VCR and/or television will have separate inputs for VHF (channels 2–13) and UHF (channels 14–83). Making it more complicated, some antennas (usually rabbit ears only) also have separate connectors or leads. To avoid complication, first try making only the VHF connection. In many cases this will be all that's needed to give you both VHF and UHF. To test it, try to tune the various UHF channels. If this doesn't seem to be working out, you will have to provide the appropriate signals to each of the device inputs.

The antenna lead might be already carrying both. In this case all you need do is split the signal. A special signal splitter is available

FIGURE 5-26 A VHF/UHF splitter.

for this. It has separate leads for the VHF and UHF sections.

Before you buy such a splitter, make sure you need it and also check your VCR to see what kind(s) of leads you need. Typically, the VHF input will be a 75-ohm RF connector; if there is a separate UHF connector, it will probably be a 300-ohm connector.

The reverse might also cause a problem— i.e., when the antenna has two separate leads but the device has only one input. In this case you may have to combine the two antenna leads into just one.

Once again, first try connecting just the VHF lead to the VCR. It's possible that the UHF signal is there, even if there is a separate lead for UHF. If it's not, you can use a standard signal splitter to take care of combining the signals. (See "More Than One Set" below for more on signal splitters.) Despite its name, a signal "splitter" works just as well as a "combiner." (It can split one signal input into two or more signal outputs; or it can accept two or

FIGURE 5-27 A standard signal splitter.

more inputs and combine them into a single output.)

CABLE TELEVISION CONNECTION

If you are hooked up to a local cable television company, you probably won't need an antenna. The local channels will be provided as part of the package service. (However, consider having at least some rabbit ears on hand for those times when the cable goes "off the air.")

Generally, the signals from the cable company are fed into a converter/tuner box. With this scheme, the VCR/television would be left on a preset channel (usually 2, 3 or 4), and the box will be used to change channels. The problem with this is that you won't be able to record one channel while watching another.

The solution is to get a "cable ready" VCR/ television. This way the cable company's signals are fed directly to the VCR/television, the box is eliminated and your VCR/television handles the channel selection.

These days, almost all VCRs are "cable ready." This makes it possible for you to have separate tuning of the VCR and a "noncable" television without having two selector boxes. The cable bringing in the signal goes to the input of a two-way signal splitter. One output goes to the selector box, which in turn feeds the television. The other goes to the VCR. You can now watch one channel while recording another.

Unfortunately, this can bring a complication, but one which is easily solved.

Usually, the cable signals will fill all the channels. This means that when you try to playback a tape on channel 4, the television set is already receiving a signal on that channel. The result is interference. The solution is to add an RF switch. (If the television *is* "cable ready," you may be able to feed the signal directly through the VCR, in which case the VCR/TV switch in the VCR will act as the RF switch.)

FIGURE 5-28 RF switch.

The RF switch has two (or more) inputs and one output, with the switch selecting which input will be used. In this case, one input comes from the cable selector box, the other from the VCR, with the output going to the television.

STEREO

If your VCR is stereo, and even if it isn't, you may wish to connect the audio portion through your home stereo system. Doing so can be extremely easy—or impossible. It depends almost entirely on the inputs to your home stereo.

The stereo unit should preferably have "video" inputs on it if making this connection. (On an audio stereo unit, this label means that it accepts the audio portion from the video equipment.) This gives you the needed inputs without having to unplug something else, and it gives you switching on the front panel of the unit.

The audio inputs/outputs are almost invariably phono jacks and plugs. A stereo VCR will have two outputs (left and right). A VCR without stereo will have just one audio out. To get stereo you obviously need to take a stereo signal from the VCR and feed it into a stereo. This doesn't mean, however, that you can't feed the audio of your monaural VCR into the home stereo.

If you take the single audio output and feed it into just one of the two channels of the stereo, you'll get just one channel of sound. However, by using a 'Y' patch cord, the audio output of the VCR is split so that the signal can be fed to both channels. The sound you get

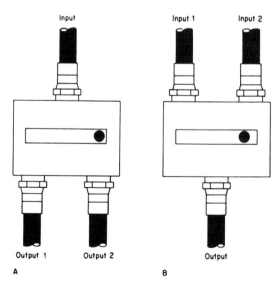

FIGURE 5-29 Hooking up the switch.

FIGURE 5-30 An audio 'Y' patch cord can give you simulated stereo.

from each side will be the same, but at least you'll get sound from both channels.

MORE THAN ONE SET

The easiest way to drive more than one set is to use a signal splitter. This inexpensive device is like a miniature junction box, with one main cable coming in and two or more cables coming out. Signal splitters can be purchased with either 75–ohm or 300–ohm terminals, or a combination of these (usually with built–in matching transformers—but be sure to check the package or ask the salesperson).

To send the VCR output to two or more television sets, run the output to the input of the splitter, then run cables from the splitter's outputs to the television sets.

FIGURE 5–32 Distribution amp.

More expensive but much more effective is to use a "distribution amplifier" instead of a splitter. The signal is then both split and boosted. If you are feeding more than 3 television sets from a single VCR or antenna, you may need a distribution amp. (A signal can be split just so far before the strength of the signal suffers.) You can buy a distribution amp at many electronic supply stores for between about $20 and several hundred dollars, depending on the power, complexity, and quality.

The distribution amp must be plugged into an electrical outlet to get the power needed for the amplifiers which boost the incoming signal. The amplifier draws very little current and can be plugged into almost any circuit without fear of overloading breakers or fuses.

The distribution amplifier hookup is very much like using a splitter. The signal is connected to the input of the amplifier. Then 75–ohm coaxial cable is run from the outputs of the amplifier to each of the television sets in the home.

If you wish to have control at the remote set—to be able to watch television while someone in the main room is watching a video tape—two cables are needed. One cable carries the

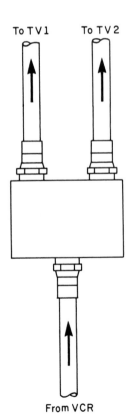

FIGURE 5–31 Using a splitter to feed two TVs.

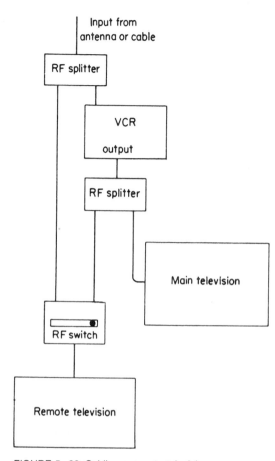

FIGURE 5-33 Cabling a remote television.

FIGURE 5-34 Draw boxes for the various pieces of equipment.

television signal; the other carries the signal from the VCR. An RF switch is needed at the remote site. The two cables are attached to the two input terminals, with the output terminal connected to the remote television through the switch.

You can now select which you want to watch. Flip the switch to side "A" and the normal television signal is fed into the set. Switch it to "B" and the signal from the VCR is accessed.

MORE COMPLEX SET-UPS

With some planning and a bit of common sense, you can design a signal distribution system to meet any need you might have. You can split or combine signals with splitters. Signals can be split and boosted by using distribution amplifiers. RF switches can be used to split and control the signals. In addition you can buy various audio/video control boxes that are capable of accepting and controlling a number of inputs and outputs.

The key is planning. Draw boxes to indicate the various pieces of equipment that need to be connected. On these, indicate the various inputs and outputs that will be used.

Draw lines with arrows and labels (or you can use color) to show the signal paths. Draw these lines near but not touching the input/output. You might find it easier if you do the design from the input side. For example, if your plan will have three television sets and each will need inputs from a VCR and a cable, draw a line from each TV back to the sources of the signals. Once you have these lines in place, you

FIGURE 5–35 Put in lines to indicate signal paths.

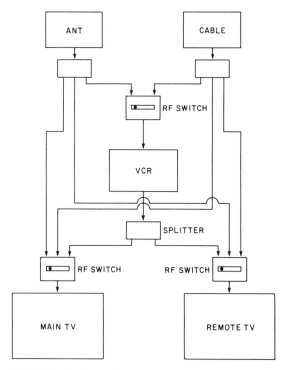

FIGURE 5–36 Figure the easiest way to split and otherwise control those signals as needed.

can figure out how the signals have to be distributed.

As above, signal splitters and RF switches will take care of most designs. If you get the impression that your design is getting too complex, it probably is. Make some new sketches of the wiring scheme to see if it can be simplified.

SUMMARY

Most of the connections of the VCR will be through either an RF connector, the spade lugs of a 300–ohm connector, or through phono plugs. While you can buy some of the wires and cables premade, doing so for a more custom set-up won't be possible. In any case, making your own cables is simple, especially if you use solderless connectors.

The best wiring is done by using cable. The 300–ohm twin–lead antenna wire can lead to

degradation or loss of signal. Cable is much more efficient and usually makes for a neater installation.

Most of the connections between television sets and VCRs, or VCRs and VCRs, require little more than a bit of common sense and preplanning. By using signal splitters, switches, and some ingenuity, you can basically do anything you wish. Distribution amplifiers can be used both to split the signal and to boost that signal if you are using multiple television sets.

Keep things simple. When you've sketched the plan for what you have in mind, look it over carefully to see if you can simplify it. Quite often you'll find that your original idea is doing things the hard way.

Make a complete sketch of your connecting scheme. Sooner or later you'll be glad that you have it as a reference source.

Chapter 6

The Tapes

As was mentioned in chapter 4, the first video machines used reel–to–reel tapes. Not only were the tapes expensive, threading the tape through the machine was a bit tricky.

Audio cassettes had been around for some time. Sony took the basic principle and devised a way to make it possible for cassettes to be used in video and the first VCR was invented.

The introduction of cassettes to the video industry proved a major boon. It allowed manufacturers to mass produce machines that are extremely simple to operate. In fact, modern VCR units are so non-technical in operational design that it has been said that using a VCR is "as simple as dropping a letter in a mail box." The machine does everything for you.

Not only is the video cassette easy to use, it also helps to protect the tape. The cassette is pushed into the slot to a point where a mechanism unhinges the front flap and then pulls the tape out and winds it along the tape guides and across the heads. This is done automatically and without the need for tedious feeding of the tape by hand. Your fingers never touch the tape.

However, cassettes aren't faultless. In actual fact, of all VCR malfunctions, at least half are caused directly or indirectly by the cas-

settes. While this doesn't always cause damage to the VCR, it *could* easily mean a ruined tape.

The cassette is a relatively delicate mechanism. In order to be as inexpensive as possible, the plastic construction is not extremely sturdy. It is very easy for the spring–loaded protective flap, the plastic hubs, or ratchets that allow the tape to be moved properly back and forth inside the cassette to become broken or to shift out of alignment. If the cassette is not functioning properly, the machine will not be able to load the tape.

SOME IMPORTANT PRECAUTIONS

By following a few common sense precautions you can greatly increase the life of the tapes and of the VCR.

1. Buy ONLY quality cassettes
2. Avoid moisture
3. Don't bump or jar the cassettes
4. Never touch the tape
5. Don't use a cassette until it has reached room temperature
6. Keep the cassettes in their boxes and away from dust
7. Rewind completely before storage
8. Store in a cool, dry place

9. Store vertically only, never flat
10. Keep cassettes away from magnetic objects
11. Fast forward and rewind all tapes that have been in storage for long periods

QUALITY MAKES A DIFFERENCE

Trying to skimp on cassettes is foolish. The 50¢ or $1 you save could cost you the heads of your VCR—or worse! The problems are caused by both the case and the tape.

The plastic-based tape is manufactured in several grades. The best grades are generally used for video and delicate computer recording media. Sometimes lesser (or economy) grades will work in a VCR recorder—or will *seem* to—but several things might happen.

- You'll usually get not just one "bad bargain" but two. The company which tries to save a few pennies on the quality of the tape will likely try to save on the quality of the cassette. Almost immediately you'll notice that the recording and playback quality suffers.
- Worse, the magnetic material might begin flaking off. This not only ruins the recording but it drops those deposits inside the VCR. Within a short time the heads can become so coated that even a thorough cleaning won't remove them.
- The "bargain" tape also is more likely to be causing excessive wear to the heads and transport mechanisms.

Use of quality recording tape will lengthen the life of your machine. The better tape will also last longer and cause fewer problems. Stay away from the so-called "bargain brands." Stick to the name brands that are recognized as being at least adequate. What this means in general is that you're likely to end up with decent and reliable tapes and cassettes. If you buy cassettes that are of an unknown brand name, you're taking the chance that the tape, cassette, or both are of inferior quality.

Just because a tape *says* that it is of higher grade doesn't necessarily make it so. Even with the name brands, a tape that *says* it is the Ultimo–Supreme Professional Grade, costing two to three times as much as anything else, may actually not perform as well as the same company's standard grade. At least yearly, some independent lab or another will release their findings on comparative tape qualities. It's to your benefit to check out one or two of these.

REWINDING

After playing a tape, rewind it all the way to the beginning. Then remove it from the machine and return it to its protective case. If you have one, keep the cassettes in the special storage box.

Even with all the precautions you've taken to keep dust off the cassettes, it's a good idea to wipe them occasionally. (Never the tape itself—just the outside of the case.

If a tape has been sitting unused on the shelf for an extended period of time, use the fast forward and rewind functions of your VCR before putting the cassette in for recording or playback. Running from end to end in this way, all the way forward and all the way back, will repack the tape. The reason for this is to make sure that the tension on the tape is equal along the entire length.

A good investment is one of the separate units that do nothing but fast forward/rewind. These save on the motors of your VCR. Even a unit that does nothing but rewind can reduce the amount of wear on the VCR motors.

These rewinders can be as complicated as you wish. They can be battery powered or plug into the wall. (AC powered units are to be preferred.) Some just rewind while others can go in either direction.

Some have erase heads built in to clean away unwanted recordings. These work much better than the typical erase heads in a VCR. A few manufacturers claim that the erasing returns the tape to almost original condition, with NO unwanted signals left.

A relatively new kind of rewinder now available safely cleans the tape each time you move it through the device. Some, such as the *Visionperfect* unit, can go in either direction, can be operated from AC or battery, and offers your choice of dry or wet methods of cleaning. It also cleans both sides of the tape rather than just one.

Think about it a moment and you'll see that cleaning just one side is rather useless. That clean side will immediately come into contact with the unclean side—and so much for the cleaning.

A rewinder that also cleans the tape (both sides!) is especially valuable if you plan to rent tapes. The investment can save your VCR heads by preventing unwanted contamination from getting inside.

STORAGE

Once you have made the effort to get quality tapes, make the effort to handle and store them correctly. A recording is made and played via magnetic fields captured on the tape. Keep the cassette away from any magnetic field. Electric motors, power transformers and other devices generate magnetic fields strong enough to erase tapes. Better yet, use a storage case to further reduce the amount of dust. Any bit of contamination can ruin the recording, and can also get inside the VCR to damage the sensitive parts.

Note: This should also serve as warning when you go to rent tapes. The tapes are only as clean as the machines that have played them. Just as a dirty tape can deposit contaminants inside a VCR, they can pick up contaminants, only to deposit them later inside someone else's machine. Normally, this isn't a serious problem. The amount of filth per tape is relatively small (as long as the suppliers are using decent tape). Still, it adds up. If you intend to rent tapes often, plan on cleaning the inside of the machine more often.

Store the cassettes on edge, never flat. Despite the light weight of the tape, even that little

FIGURE 6-1 Tape storage case.

can cause crimping on the edges. If that wrinkle is on the audio side, you'll lose a part (or all) of the sound. If it happens on the side that holds the sync track, you might as well toss the cassette into the trash. It will never play correctly.

Be sure that the place for storage is cool, dry, and clean. Finally, if a tape has been in storage for a long period of time, fast forward and rewind before using it. (That includes purchase of new tapes.) This "repacks" the tape—getting rid of any uneven tension or spots made "sticky" by moisture.

Moisture can cause virtually immediate deterioration both to the cassette and to a VCR. In order to reduce such accidental moisture, be sure the video cassette is stored in a dry place. Also don't forget that changes in temperature can cause condensation, especially when the cassette is taken from a colder area into a warmer one. If you've done so, keep the cassette at room temperature for at least one hour before being used.

Likewise, be aware of excessive heat. More than one owner has lost a valued recording by leaving the cassette in the car on a hot day. Others have damaged their prized recordings by carelessly placing them on radiators or too near heater vent outlets. Some have found themselves having to pay for rented movies accidentally destroyed by such carelessness. Even if the heat doesn't melt the cassette, strong sun-

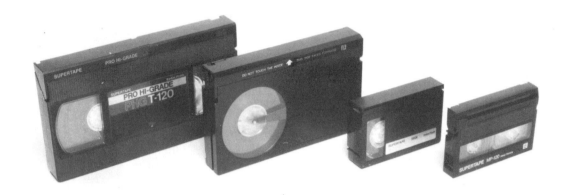

FIGURE 6–2 VHS, Beta, VHS-C and 8mm cassettes. The largest is the VHS format.

light and heat can degrade or ruin the recording.

Never touch the surface of the tape. This is one reason for the presence of the hinged flap—to keep any of the tape from being exposed when it is not in the machine. Fingerprints and oils from your skin can ruin a tape very quickly. Dirt and grease can also damage the delicate internal mechanisms of the VCR itself.

ANATOMY OF A CASSETTE

The cassette or cartridge is a protective plastic box with the tape inside. The cassette contains two reels on which the tape is wound and transferred. The tops of these reels are flat; the bottoms are hollow cylinders with splines.

The front edge (the side that feeds into the VCR first) has a spring-loaded hinged door. It's normal position is closed, to protect the tape. A hinge lock holds the door in place. As the cassette goes into the machine, a pin releases the catch and another lifts the door up and out of the way.

With most cassettes, a ratchet locks the reels. This way the tape is never allowed to come loose. As the cassette is seated, a pin slides into a hole to release this catch. The machine can then pull the tape out and feed it through the mechanisms.

If the need presents itself, you can operate both of these catches manually. All you need is a finger for the door release. A pencil or other pointed object can be used to release the reels.

To prevent accidental erasure of a recorded program, all cassettes (except pre-recorded) have a removal tab on the rear edge opposite the hinged door. This tab can be broken off by pushing or prying it with your finger or with a screwdriver. Very little force is needed to break this tab off. After the tab has been removed, the cassette can be used for playback

FIGURE 6–3 Top view of a cassette.

FIGURE 6-4 Bottom view of a cassette.

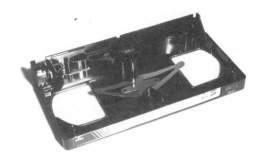

FIGURE 6-5 Inside the top.

only, and any material which has been recorded is protected from being erased. If at some time you decide that you *want* to record on that cassette, merely cover the hole with a piece of tape.

The case itself is two pieces held together by 5 (usually) small Phillips–head screws through the bottom of the case. With these removed, the cartridge will come apart easily. (See the next section on "Tape Repairs" before attempting to open the cassette.)

Inside the top lid, and attached to it, is a spring-leaf. Its purpose is to put a slight amount of pressure on the reels to hold them down. Also a part of the top is the hinged door and a spring to close it.

The bottom half is more complicated. On the take-up side is the door release button and an attached spring. The tape is threaded through a slot between a plastic roller and a smooth metal sleeve on a plastic pin. On the supply reel side is another sleeve. The tape goes around this, then between a pin and a piece of flexible plastic (used to press the tape gently against the pin).

At the back are the spring-loaded forward and reverse rachets. These catch on "teeth" on the bottoms of the reels. Between them is the release. (This is moved through a hole beneath it on the outside of the bottom.)

Actually, it sounds more complicated than it is. The first time you take apart a cassette may make you nervous. It should! There are lots of little parts inside that can go flying. However, once you've been inside and have seen where the parts go, you'll have no problems.

TAKING APART A CASSETTE

Why would you ever want to get inside the cartridge?

There are several reasons. One might be that the cartridge has become damaged or warped. If the recording on the tape is important, you certainly don't want to throw it away. Removing the tape from the damaged cartridge and putting it into a new one is fairly simple.

It's also possible that the cartridge will be fine but some damage has happened to the tape. However, the damage is almost always in just

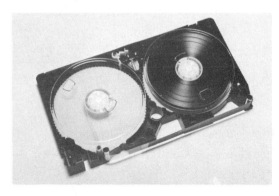

FIGURE 6-6 Inside the bottom.

The Tapes **55**

one place. If a foot or so of the tape has been ruined, you do NOT have to throw away the whole thing. You can make repairs and salvage at least most of the recording.

Although virtually every book, article, or manual on VCRs will warn you to *never* splice the tape, the job is relatively simple to do, and sometimes the only way you can save a valued recording.

To swap a tape you will *have* to open the cassette. To remove a damaged section then splice you can get by without opening the cassette, but the job is usually much easier if you do.

Turn the cassette over, with the label side down on the table. Carefully remove the screws that hold the cassette together. (If there is a label on the back edge, you will have to remove this, or at least slice it along the crack between the two halves.) If you can't get the screws out, they'll fall out or at least move out of the way, in the next step. The only problem is in having them get lost.

Grasp the cassette with both hands and VERY CAREFULLY turn it over so that the label is up. Now put both hands on the top half, with your fingers gently holding the hinged door, lift the top. If it doesn't come off easily, don't force it. Check for screws etc. you may have missed. If you've removed all the screws, edge labels, etc., the top *will* come off easily.

TAPE SWAP

Swapping cartridges (actually, swapping the tape inside) is simple if you first look to see how the tape is threaded and where all the parts go. It's possible that you'll bump something out of place and will have to put it back. You can refer to Fig. 6–6, but it's much better if you have a personal familiarity with the inside of the cassette.

The swap requires two cassettes (obviously), which means that you have to take apart both. At least the first few times you do it, take off the lids of both cassettes, but don't touch the reels yet. Then, very carefully remove the tape from the good cartridge (the tape that is to be discarded) and set it aside. Now inspect the insides of both to be sure that you haven't bumped any parts out of place.

You can now remove the tape you want to keep, but before you install it in the good cartridge, look at the parts once more. Are the positions of the parts in both cassettes the same? If so, you can now proceed to put the recovered tape into the new cartridge.

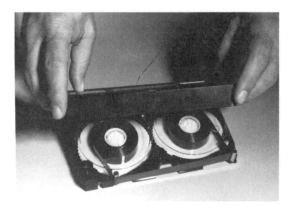

FIGURE 6–7 With your fingers on the door, gently lift off the top.

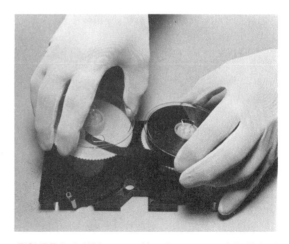

FIGURE 6–8 Without touching the tape, carefully lift both reels from the cartridge.

All that's left is to replace the lid, turn the cassette over (carefully, and with both hands) and screw it shut.

TAPE REPAIRS

Repairs are slightly different. How you handle it depends on where the damage is and our own preferences.

Despite what you might have heard, video tape *can* be spliced. The problem is in having that splice go over the video heads, and especially so if the splice is sloppy. This can cause damage, even to the point of destroying the heads and forcing a replacement.

Such an extreme is fortunately rare. It's also irrelevant if the recording is irreplaceable and of greater value than even a whole new VCR. Again, this is an extreme which assumes the worst possible splicing. Most of the time, splicing is no problem at all. Especially if you do the job right and take the proper precautions.

WARNING

Although splicing is possible, avoid it whenever possible. It should be a last resort ONLY! Splicing can cause damage to the VCR heads.

Before getting into the mechanical operations of making a repair, let's see how a splice is done. (All of the following repairs require the process.)

Tape Splicing

Ideally, the splice will be done in a place that will not cross the video heads. This means that it would be done on the clear leader fairly close to the reel. *DO NOT* remove any of the leader, if possible.

Sensors inside the VCR make use of the clear leader. A light is shined on the tape. As long as recording media is passing through, the light can't penetrate and the tape continues to roll along. The moment the clear leader comes,

the light passes through and activates an automatic feature, such as auto-rewind or auto-shutoff.

Both features are important and both prevent serious damage from being done. For the sake of your VCR, be sure that enough clear leader is left so that these features are secure. Locating the sensor(s) shouldn't be difficult. Once you have, you can estimate the amount of clear leader needed.

Ideally, a splice should not go across the heads even once. You risk causing damage by doing so. If you *must* make a splice in a place that will move over the heads, your next job will be to make a dub of the tape. Use the dub as your playback copy and stick the repaired original in storage. All in all, you're better off letting a splice go across the heads once to make the dub rather than removing the clear leader and letting the VCR motors continue running when the sensors fail to recognize the end of a tape.

Wherever you make the splice, the technique is the same. Unfortunately, video splicing tape isn't readily available to the homeowner. Usually, you'd have to locate a supply house that carries products for the professional but still willing to deal with you. For most of us, that consigns us to using regular transparent tape for the job. This is too thick, too imperfect, and has the tendency to have the glue "leak" beyond the edges, but when there is no other choice

This is one time you will be breaking the rule about never touching the tape. You'll have to touch it. The oils and other contaminants on your fingers can cause other damage. At very least, wash your hands thoroughly—which means rinsing them thoroughly, too. Residue from soaps can be just as damaging as the contaminants you're trying to wash away.

Better yet, spend the 50¢ or so to get a pair of lint-free photographer's gloves. These are available at just about any fair–sized camera store. They're designed for handling deli-

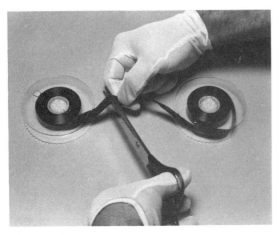

FIGURE 6–9 Cut the tape to remove the damaged section.

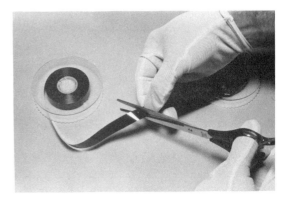

FIGURE 6–11 . . . and cut at an angle.

cate photographic negatives, which makes them suitable for this job as well.

The easiest way to do the cutting is to begin by making rough cuts just to remove the damaged portion. That gets the section out of your way.

Next, place the two sections to be spliced together, with one side overlapping the other. Take care to be sure that the side edges are perfectly flush. This will mean that some good tape will be wasted (maybe a second or so), but it's worth it.

Cut through the overlapped tape. It's best to do so at an angle of approximately 45 de-

grees. You'll end up with some small scraps of tape and two ends matched for angle. Toss out the scraps. Your task is to join the two matched ends. Be sure that both are perfectly aligned.

The Repair

There are two ways you can go about splicing only to the clear leader. One is to make the cut, discard all the tape from one reel and splice to the leader. The other is to use the tape swapping method as described on page 56 for one of the reels.

The easiest method is to discard all the tape on one side or the other of the damage. For this, you simply take the cassette apart, cut the tape with a scissors on the side you wish to save, unwind the other side to the clear leader,

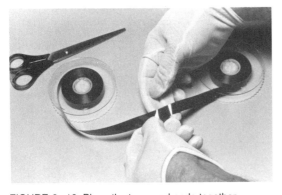

FIGURE 6–10 Place the two good ends together

FIGURE 6–12 Very carefully place the two ends together and tape them. Be SURE that the two ends align perfectly!

FIGURE 6–13 Trim the excess.

cut this, throw away the unwanted tape, and splice the wanted tape to the leader.

This can be done without taking the cassette apart, by inserting a pointed object in the ratchet release hole, holding the door open, and pulling the unwanted tape out. The problem is that it's all too easy for the door to swing shut again or for the ratchet to re-engage.

If the entire tape is of value and you don't care to discard any of it, you'll need a second cassette. The tape in this second cassette will be thrown away. All you're after is the cassette, the reels, and the attached leader on each.

Open both cassettes. Use a scissors to remove the damaged tape from your original cassette. Next cut the tape of the second cassette from the leader, unwind the reel full of tape to the second leader and cut. You now have two partially filled reels with the tape you want to keep and two reels with only leader. Swap one partially filled reel with one empty reel, splice the tape and leaders in both cassettes, and put everything back together.

You'll end up with part of the recording on one cassette, and part on the other. If this isn't convenient, you can make a dub for the main playback copy and store the originals.

Regardless of the kind of repair you've done, before trying to playback or record such a repaired cassette, be sure to fast forward and rewind it from end to end at least *twice*. This will help the tape to resettle and properly repack.

THE VCR'S LOADING MECHANISM

Top loading machines have been almost completely replaced by front loaders. With the top loading machine, the cassette is placed into a "rack" and then manually pushed down into the machine. With a front loading VCR, a sensor recognizes that the cassette is being inserted, causes it to be grabbed and brought inside. It's then lowered into place.

Either way, as the tape moves into place one pin releases the hinged door and another releases the ratchets that hold the reels in place.

The cassette is lowered over a vertical metal pin. This pin is on an arm or lever which is attached to a large circular ring. This is called a *threading ring*. When the VCR is used for playback, the ring rotates and causes the arm and pin to pull the tape out of the cassette and around the threading path across the heads. When the threading has been completed, the threading motor stops and a solenoid is used to clamp the pinch roller against the capstan. The tape can now begin moving in its normal direction along the tape guides and across the rotating video head assembly.

Whenever a stop button is pushed, the threading ring rotates unwinding the tape from across the heads and the tape guides, then places it back inside the cassette. The machine can thus fast forward or fast rewind without having the tape crossing the heads. (If it did, there would be needless wear on the heads and on the tape.)

The entire loading and unloading operation is completely automatic. Because of this automatic feature and the simplicity of the cassettes, the mechanics of the VCR unit are more complicated than those of the reel–to–reel video tape machines. A complex system of levers, rods, rollers, and servo-mechanisms make up the mechanics of the VCR. Adding to this com-

The Tapes **59**

plexity, the number of electronic circuits that control the mechanics make the newer and/or fancier VCR more complicated for servicing than the older and more basic units.

Despite the complexity, surprisingly few things go wrong. You can greatly reduce even this by keeping things clean, by using quality tapes, and by using common sense.

For example, it takes a couple of seconds for the mechanisms to do the job. During this time don't touch the other controls. In a sense, this is like trying to force the tape and mechanisms in two directions, or two speeds, at the same time. Most modern VCRs have protective devices that prevent the controls from operating while the tape is threading, but it is still possible to damage the machine or tape by pushing the selector switches while the cassette is threading. Don't trust the protective devices.

Also, avoid going from one function to another too quickly. If you're in the fast forward mode, don't just press "Play." The VCR will probably handle it just fine. It will come to a stop, and then go into the loading process. However, if something in the mechanism is marginal, you could find yourself with broken or tangled tape.

TANGLED TAPE

One of the more frustrating things to have happen is when the VCR begins to "eat tapes"; something has gone wrong and the tapes end up getting mangled. You find yourself having to remove a cassette along with several feet of tape wrapped around places it shouldn't be. The trick is to go slowly and carefully. This is *not* the time to take out your frustrations. If you rush or force, the chances of causing damage to both the tape and the machine are high.

Learn how your VCR sounds. Become aware of the noises it makes in loading and unloading. That way you'll more likely hear when things start going wrong. For example, when you press "Stop," normally there is a

distinctive click when the unthreading is complete and the tape is back inside the cassette. If you don't hear this, it could be that there is a small portion of tape still outside. Ejecting will cause the door to slam down on the tape. Worse, it could catch on one of the pins, etc. inside the machine and pull out even more tape.

If you're in doubt, press "Play" again, let the VCR go through the threading cycle and then press "Stop." If you still haven't heard the click, shut off the power. (Some experts recommend going so far as to unplug the unit.) By removing power, any tension caused by the motors is removed, and the purely mechanical parts might work when they didn't before.

If you hear the tape being dragged and mangled inside (usually like a soft grinding sound, often accompanied by a buzzing), press "Stop" immediately. The longer the machine continues to run, the worse the tangle will be.

If the tangle is bad (and even if it isn't), you'll probably have to remove the top of the VCR. This gives you easier access to the tangle.

The image on the television might be just fine for several seconds or longer, even when something inside has gone wrong and the tape is being jammed. The sounds will almost always come first.

As with any handling of the tape, try to have lintfree gloves on your hands, and be careful to keep them absolutely clean. (They're inexpensive enough to be disposable.) Without gloves, all you can do is to wash your hands and hope that you don't contaminate the tape.

Carefully untangle the tape until a loose end, free of all the machinery, is available. Work with this slowly until all of the tape is free.

You'll probably have to turn the power back on and eject the cassette. This brings another danger. Several, in fact. It requires that your hands be inside the VCR. To avoid further damage and to keep things under control, you'll have to cradle the cassette and loose tape out of the machine. To avoid danger to yourself, do the untangling with the power off (and with

the machine unplugged). Once the tangle is free, get your hands out, apply power, and press eject. Then shut off the power again. Now the only danger is to the cassette, tape, and VCR.

You'll probably have to let the cassette's door come down on the tape. Both of your hands are needed elsewhere. One will be holding the VCR's door open as you pull out the cassette, and again to hold it open to remove the tape.

Once you have it all out of the machine, you can examine the tape to find out if the damage to it is minimal enough to wind it back into the cassette, or if you'll have to do some cutting and splicing.

SUMMARY

The quality of the tapes used can make the difference between reliable enjoyable recording and playback—and headaches. Of all the problems with VCRs, more than half are caused directly or indirectly by the cassettes. The "bargain brands" are usually no bargain at all. At best you'll get a poor quality recording and a short tape life. You can also cause expensive damage to the machine. Buy *only* quality tapes from reputable and known manufacturers.

You can greatly reduce the problems and increase the life of your tapes by taking care of them properly. Handle them carefully at all times. Never touch the tape with your fingers. Also important, learn how to store them correctly.

If the cassette case is warped or otherwise damaged, the easiest repair is by simply swapping the tape from the bad cassette case to a case that is known to be good.

If the tape is damaged, you can carry out repairs to save a valuable recording. One method is to cut out the damaged section of the tape up to the leader, then splice the wanted tape to the leader. For more serious problems, tape can be spliced in an area that will cross the head. In this case a dub should be made for playback and the original stored. This method is a last resort, to be used *only* for irreplaceable recordings. The splices can cause serious damage to the record/playback heads of the VCR.

Tangled tape can be worked out of the machine if you are patient and gentle. Sometimes the tape will not have been damaged by the tangle. If it has been damaged, go back to the information on tape repairs and splicing.

Chapter 7

Periodic Maintenance

There's no better way to solve problems than to keep them from happening in the first place. This means first that you should learn how to operate the equipment properly. The more complicated the equipment, the more important this becomes.

The other primary key is cleanliness. This begins with keeping the area around the VCR clean and ends with proper cleaning maintenance, inside and out. As childish as the constant badgering of "Keep it clean" seems, ignore this and you'll find yourself buying a new machine much sooner than you'd expected.

PROPER OPERATION

It may not seem that "proper operation" belongs in a section on maintenance, but it does belong—especially when it comes to video equipment other than the VCR.

Operating the VCR itself is generally very simple—almost foolproof. There isn't much you can do wrong. Even so, thoroughly read the manual; learn the machine well and its capabilities. The same applies to other video equipment. Failing to do this can mean frustration when you try to get the equipment to do some-

thing it can't or when you damage it in the process.

Although this is most important when you first get the equipment, it can also be important as a part of your regular "maintenance," especially if you don't use the equipment often.

BASIC CLEANLINESS

Outside the VCR

Cleanliness is the key to long life and top performance. You can't keep your machine working perfectly forever, but these steps can decrease the number of major (and minor) malfunctions. The majority of malfunctions come from lack of cleanliness. VCR cleanliness should become a constant concern.

Keep ashes, food particles and liquids away from the machine. Dust and dirt or spilled coffee can do tremendous damage to your machine. Keeping the VCR clean is extremely important, so keep the area around the machine as clean as possible. A dust cover is an inexpensive investment, and one you should have. If you didn't get one with the VCR when you bought it, make getting one your first project. More important yet, *use it!*

WARNING:
Do not operate the VCR with the dust cover in place. This will block off ventilation and cause overheating that will lead to equipment failure.

Even if you have a dust cover, clean the outside of the equipment regularly. (Doing so daily isn't too often.) Don't just move the dust around. Remove it. The cloth can be one impregnated with special dust-lifting chemicals. This will help keep that same dust from filtering down inside the machine, and will reduce the amount of dirt that you yourself transfer as your fingers touch the machine and then the cassettes. If you use a damp cloth to remove the dust, be sure that the cloth is just barely damp, and then use a clean, dry rag afterwards to remove as much of the moisture as possible.

Tapes

Cleanliness doesn't stop at the machine. Dirty tapes can also cause considerable damage. Dust, ground–in dirt, grease, or other contaminants on a tape can cause drop-outs in the picture and can eventually damage an entire tape cassette. Worse, the grime from a dirty tape can contaminate your VCR, which can not only ruin the machine but any other tapes played in it.

Even if you are particularly careful in use and storage of your own video recordings, you stand this risk of having dirty tapes causing damage to your machine. A tape can pick up dust particles and grease from one machine and transfer them to another. This is an especially important concern if you plan to rent (or borrow) tapes to play in your machine. They may have been previously played on other grimy, poorly attended machines. This will then be transferred to your own clean machine.

Don't be like one of the many people who keep the outside of the machine clean and then forget that a dirty tape can create havoc inside.

There are available video tape rewinders which not only rewind (and fast forward) but clean the tapes in this process. If the one you

have in mind cleans only one side of the tape, don't bother. Unless both sides are cleaned, the untouched dirty side will simply re-contaminate the other.

More important, don't try to save a dollar and buy cheap tape of an unknown brand. It *might* be just fine. Chances are greater that the cheap tape is going to leave harmful deposits inside while also giving you poor recording quality.

Moisture

Moisture inside video equipment presents several dangers. Not only can it cause some of the metal parts to rust (including the video heads), it can cause the dust to clump and can also cause the tape to stick to the head assembly.

The best way to avoid moisture is to keep the machine at a constant temperature. Each time the temperature around the machine goes from warm to cool, condensation can take place. If this condensation is on the outside of the cabinet there is no problem. If it's inside, even invisible droplets of moisture can cause serious damage.

If you live in an area where the humidity is high, packets of silica gel might help to absorb the moisture before it does damage. Nicely enough, these packets are inexpensive. They are also reusable. (After they have absorbed their "quota" of moisture, simply bake them in an oven at low heat for a short time to drive the moisture out.)

The packets are usually made of paper or fiber, neither of which will conduct electricity. You can normally place them anywhere inside or outside the unit. The main precaution is that you be careful to keep them well away from any moving parts. Inside a VCR this isn't as easy as it may sound. Take your time and be sure that the packet is in a safe place. Tape them in place so they won't shift around if the machine is moved.

Inside the VCR

Each time you open the VCR, give the inside a cleaning. This requires care. There are

FIGURE 7-1 Be sure that the silica gel packet is away from all moving parts and is secured in place.

delicate parts inside that are easily bumped and damaged.

Some recommend using a vacuum cleaner (with the proper attachment). This is fine, but ONLY if you're very careful. It's too easy to cause more damage than any amount of dust would. Even having too much suction can cause damage. A careful manual cleaning is much better.

A clean lintless cloth (do NOT use a cloth dampened with water) can be used for some of the larger areas, such as the loading platform. For smaller, more delicate areas you can use swabs. Use ONLY those with tight tips so that threads don't come off. You can reduce this problem and increase the effectiveness of the swab by dipping the end in alcohol. For this

use ONLY technical grade isopropyl alcohol. It should be *at least* 95% pure, and preferably 99%. The only other choice would be liquid freon.

As the tape is pulled from the cassette, it is fed through a series of from 6 to 12 tape guides. These are usually upright tracking pins made of metal or plastic. Closely associated with the tape guides are the various rollers, capstans, and the threading ring. (See Chapter 6 for a detailed discussion of the way tape moves through the VCR.)

All these things can become dirty. The tape deposits its oxides and binder on these parts (and on the heads). In turn, the tape can pick the contaminants up again, making the problem of a dirty mechanical tape transport a proverbial vicious circle.

Any place that the tape touches should be cleaned on a regular basis. You can use cotton swabs on these parts if you wish. Cleaning pads are to be preferred, as the swabs *can* drop off tiny fibers which could cause problems later on. Once again, use the pure isopropyl alcohol—everywhere except the rubber parts. Don't bring the alcohol anywhere near them. It will cause them to dry out and "age" prematurely. To clean the rubber rollers get a cleaner specifically designed for rubber. (Freon will do fine.)

The key is to be gentle. Some of these parts

FIGURE 7-2 Large areas, such as the loading platform, can be cleaned with a lint-free cloth.

FIGURE 7-3 Clean all surfaces that come in contact with the tape.

are easily bent. Be very careful not to cause any damage.

Some of the older VCRs had circuit boards that plugged into slots. The idea was to make swapping out the circuit boards as easy as possible. This is rare today. Most have circuit boards that are securely anchored into place, with the connections being made with plugs and connectors.

Occasionally the contacts may acquire a coating either of grime or corrosion. This doesn't happen often, but when it does it can cause a very serious malfunction. If nothing else, the unit will begin to behave erratically. Quite often merely unplugging and reinserting the circuit boards will cure the problem. (Do this with the POWER OFF!)

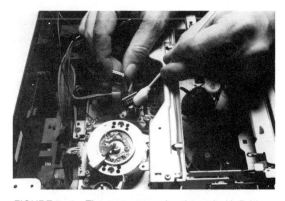

FIGURE 7-4a The contacts can be cleaned with fluid . . .

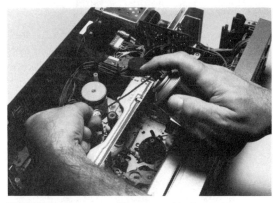

FIGURE 7-4b . . . or with a nonresidual spray.

If this doesn't work, the solution is to clean these contacts. Unplug the connector. Use a high spray quality contact cleaner. If need be, you can use the pure isopropyl alcohol to clean the pins.

The cleaning fluid used MUST be pure, and contain no lubricants. The spray called "tuner cleaner" is not to be used. It contains lubricants which will only make the problem worse.

HEAD CLEANING

As the tape goes through the VCR and across the heads, all sorts of things happen. As the recorded image is stored or played back, the tape leaves tiny amounts of dirt, oxide, and binder behind. As this builds up, the gap between the tape and the heads increases, causing a loss in image quality. Let this buildup continue unabated and it can become a permanent part of the heads. The only thing you can do if this happens is to replace the heads.

As usual, this doesn't have to happen. All you have to do to prevent such a costly repair is to keep the heads clean. The first step is to keep the machine and surroundings clean. Second, be sure to use only high quality tapes. Third, make head cleaning a regular part of your maintenance routine. The heads need to be cleaned after each 25 to 50 hours of operation (after each 20-25 movies, for example). You can vary this schedule depending on how you use the machine, the quality of the tapes you use and the surroundings. Regardless, unless the VCR has not been used and has been kept covered, plan on cleaning the heads once per month.

There are special head cleaning cassettes that you can use. This is the easiest way to go about it. It is also the worse way when compared to manual cleaning. Even the best cleaning cassettes can't do as efficient a job as can a cleaning pad and fluid. For example, they can't effectively clean the tape guides or other

transport mechanisms. They won't even touch the dirt that builds up elsewhere inside.

These cassettes have also been known to leave behind harmful deposits. One of the "bargain brand" kits can actually make the machine dirtier. Even worse are the ones that attempt to physically scrub the heads clean. This abrasive action severely shortens the head life.

Although cleaning cassettes are a bad way to go about keeping the machine in order, they are still better than nothing. If you're not inclined to do the job by hand, find the highest quality cleaning kit available and use it. (Expect to have problems sooner or later.)

Some people keep a cleaning cassette around for quick, occasional cleaning, then every few months take the time to open the cabinet and do the job manually to be sure that everything has been cleaned thoroughly. If you decide to go this route, start by getting *only* a top quality cleaning cassette and don't forget that you're using the cassette as a temporary measure. As soon as time allows, get inside the machine and do the job right.

Manual cleaning of the heads is not difficult. It means that you'll have to remove the top cover to gain access, but this normally takes just a few minutes. You'll need the cleaning fluid mentioned previously (alcohol, freon, etc.—NEVER one with a lubricant), and cleaning pads. Some experts suggest using optical chamois; still others say that professional quality lens cleaning tissue is very good. In any case, do not use cotton swabs on the heads as they can leave behind tiny hairs of fabric.

Before attempting any cleaning, shut off the power. Some people are tempted to leave the power on, with the idea that the rotating head drum will clean itself as the pad is held stationary. This is a great way to destroy the heads—a horrible way to clean them.

The motion of the pad against the head is always horizontal (around the head)—NEVER up and down. This is very important. An up and down motion is almost certain to knock the

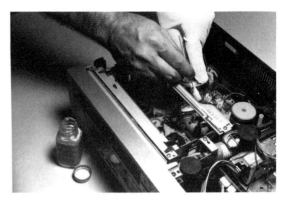

FIGURE 7–5 Hold the pad in one hand and turn the head drum with the other; or, hold the drum and move the pad around the head drum.

heads out of alignment or to cause other damage to them.

The simplest method is to hold the fluid impregnated pad *lightly* against the head drum with one finger while turning the drum by hand from the top. A second method is to move the cleaning pad around the drum while holding the drum in place with a finger. Either way, be sure that the hand that touches the drum is wearing a lintfree glove. You can get these at many electronic supply stores or even at a local camera store. (Photographers use them for handling negatives.)

Take great care in cleaning the heads. The amount of pressure needed is minimal. If you press too hard, the heads can be knocked out of alignment, or you could cause other damage. The cleaning pad should just barely touch the heads.

If you follow the instructions given and clean the heads after every 25 to 50 hours of operation, the contamination will be unlikely to have stuck to the heads. It will come off easily. Given too much time, those residues can bind themselves to the head, possibly permanently.

CHECKING THE BELTS

Each time you open the VCR for regular cleaning, take a quick look at the belts, pulleys,

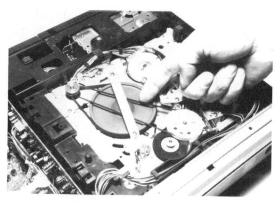

FIGURE 7-6 Check the belts for wear.

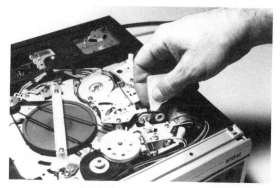

FIGURE 7-7 Dressing a belt with resin is a temporary solution.

and other moving parts. Very few machines allow access to the belts from the top, but this will help to keep you aware that they exist down in there somewhere.

You should be taking off the top cover about once a month to clean the heads and other critical parts. Every 1000 hours of operation, or every 6 months, take the time to remove the bottom cover for a more thorough cleaning and examination. You're looking for worn spots, frays, or other obvious damage. A light touch with your finger will tell you if the tension and flexibility is still correct. Better yet, use a pencil; this method doesn't leave fingerprints.

If any of the belts show signs of wear and tear, don't close up the machine and wait for the belt to break or bind. Spend a little bit of time and money to replace it right then.

If the belt is stretched and loose, it's possible that your particular VCR will allow an adjustment to keep the belt in service for a while longer. The only way you can tell for sure is to check with the service manual for your machine. Fewer and fewer manufacturers allow for this kind of adjustment. The reasoning behind this is sound.

Even if your VCR *does* allow the belt adjustment, it's a better idea to replace the belt. A stretched belt has a limited lifespan left to it. You'll have to replace it sooner or later any-

way, so why not do it while the machine is open? You'll save yourself time, money (the price of the replacement belt is *not* going to go down), and trouble and you'll have a unit that is in tiptop operating condition instead of one that is just barely getting by.

In an emergency, such as a weekend or holiday when a replacement isn't available, a slipping belt can be put back into temporary service by a light application of resin or beeswax to the inner surface. This will allow it to adhere better to the groove in the pulley.

Occasionally you might hear of someone who has successfully replaced a belt with a rubber band (hopefully on a temporary basis!). Although this *might* work, the hazards involved far outweigh the advantages. If the rubber band is too loose, it simply won't work. It it's too tight, it can yank and pull things out of alignment. You might be able to finish watching that movie, but chances are good that the next day you'll be making an expensive visit to the shop for a complete overhaul.

TORQUE AND TENSION ADJUSTMENTS

Imagine a long silk thread going from one person to another. If the first person gives out the threat too quickly, there will be a tangled mess on the ground. If the second person pulls it in faster than the first can let it out, the thread

will snap. The tape inside your VCR is like this thread, being pulled between the supply reel and the take-up reel. The tape isn't quite as delicate as that silk thread, but it comes close.

There are two tools that are used to measure and adjust this critical movement. (They are sometimes two functions of the same tool.)

1. Torque Gauge—tells you how much twist is applied by the motor, pulleys, belts, and related parts that transport the tape from one reel, through the VCR, and to the other reel. It generally is pressed onto the motor spindle (gently) to make the measurement (usually in grams).
2. Tension Spring—makes a measurement of how tight (or loose) the tape and/or the servo–mechanism springs are. There are two basic types: fan–type and spring.
 (a) The fan-type has a "stick" coming from a handle that moves across a scale as it is pulled.
 (b) The spring-type looks like one of the scales used by fishermen to see how nice a catch they made. Either way, the tension is usually measured in grams.

The actual amount of torque and tension in a VCR depends on many variables. More often than not, each unit is different from all others, even those made by the same company. The only way you can find out what the numbers are for *your* machine is to look in the service manual for that particular make and model. Even the point(s) where the measurements are made differ from unit to unit. This service manual will also show where (and how) to make the adjustments.

Do not attempt to make adjustments to the torque or tension unless you have the exact numbers involved (e.g. 170 grams) and the proper tool(s) with which to make the measurement. Trying to make the adjustment by trial and error will invariably lead to a serious error (in which case, turn to Chapter 6 to learn how to fix a broken tape or how to untangle one).

The tool(s) are available only through an authorized outlet of that manufacturer, and often they're not available at all except to repair shops. This is one time when you will probably have to bring the unit to a professional—which isn't a bad idea; at the same time this professional can check over the machine thoroughly.

CASSETTE CARE

One common cause of VCR troubles is the cassette. It not only brings on problems in itself, but it can create a variety of malfunctions and damage within the VCR. For more information on cassettes read Chapter 6.

OTHER STEPS

There are many things that can be done on a regular basis to make sure that everything in your VCR is functioning properly. For example, you might want to measure the output of your power supply to verify that it is doing its job. These electronic steps are more often a part of diagnosis than a part of routine maintenance (except for the very finicky). These are covered in the next chapter on "The Electronics."

Beyond this, each time you open your VCR give it a visual check for worn parts. Moving parts in particular are prone to wear. Springs can be stretched or bent. Rollers might become worn or develop flat spots. The gears could have been jostled out of place or had a tooth broken off.

Make it a habit to look over everything. Make notes and sketches when things are as they should be. By doing this you'll be able to spot the problem more quickly if something begins to wear, or be able to replace that part or parts before a more serious problem occurs.

The service manual for your specific VCR is the best guide for replacement of the various parts. Every manufacturer seems to have a different idea on how things should be mounted and attached. The manual will cost as much as

$25, but it is a necessary investment if you intend to make detailed repairs.

BASIC MAINTENANCE SCHEDULE

Daily (if VCR is used)
Clean outside of machine
Remove any cassettes and check for rewind
Organize cassettes (store properly)
Keep dust cover in place

25–50 hours (or monthly)
Clean heads
Clean tape transport mechanism
Visually inspect for wear
Check cables
Clean tape cassette cases and boxes

300–500 hours (6 months)
Check belts
Clean underside
Check drive gears, pulleys, etc.
Check springs, rollers, capstans, etc.
Adjust tape transport (if possible with unit—
 see Service Manual)

1000 hours (annual)
Professional check-up, including head alignment and other fine adjustments.

Occasional
Clean contacts on plug-in boards
Repack stored tapes (before using)
Check power cord for damage
Reset timing devices

SUMMARY

The key to maintenance of VCRs (and almost everything else) is to prevent problems. The easiest and best way to do this is very simply to keep everything as clean as is possible. You can't stop normal wear and tear—but you sure can reduce it.

Once every month or so (or after each 10 movies) the top cover should come off your machine and you should examine all the important parts of the unit, especially the ones that get the most wear and abuse.

Clean the heads often—more often if you use poor quality tapes or rent tapes. As long as you are gentle and perform the tasks with care, you're unlikely to cause any damage. Professional recording studios often clean the heads on a daily basis. Letting contaminants build up will certainly harm the unit and shorten its life.

All spots where the tape touches need the same attention as the heads and should be cleaned each time you clean the heads. You can use the same pure isopropyl alcohol for this except on the rubber rollers.

Clean all other surfaces as needed. The tape loading platform or bracket(s) don't actually touch the tape, but they could have tiny particles from the tape case.

About twice a year, remove the bottom cover. This allows you to check the belts, pulleys, and other parts that are hidden beneath the machine. Replace as necessary. Clean the underside while the cover is off.

Torque and tension measuring tools can be used to check out the various motors and springs of your VCR. This can't be done, however, unless you can find the proper tools for your machine and also have a listing of the correct values. Because each machine is different, the only way to know for certain is to have a copy of the service manual for your make and model. NEVER try to make this adjustment with a "Well, that looks about right" attitude. Not only will this not work, it can cause serious harm to the VCR.

Taking care of cassettes will both increase the life of the recordings and of the unit itself. Remember, those cassettes are being pushed down inside the machine. If the cassettes are dirty, they'll in turn contaminate everything else.

Because video cassettes should be re-

wound after each use (especially those sitting on the shelf for an extended period of time), a good investment is a separate rewinder. The best of these will go in either direction and will also clean the tape on both sides, which greatly reduces the amount of contamination that normally gets deposited inside the VCR.

At the end of this book you'll find a handy log to be used for your regular maintenance routine. Use it!

Chapter 8

The Electronics

Simply looking inside a VCR can be intimidating for some people; the idea of actually poking around with test equipment can even be frightening. The following pages will help you overcome that fear.

Most of a VCR's video circuits, the critical record/playback head alignment, and the complex synchronization and color amplifiers/generators are too difficult for the amateur technician to handle. They require expensive and complicated equipment to test or to adjust. Fortunately, these sorts of components rarely require attention, and if they do, it's not a job for you but for a professional technician.

You can perform a surprising number of tests with a simple volt–ohmmeter. For example, you may have a piece of equipment that is either completely inoperative or has some portion that does not work. With the VOM you can very quickly test the power going to the power supply of the equipment, the power coming out of that power supply, and the power going to and through various test points inside the VCR. You probably won't even need a service manual to know the values that are supposed to be found at the test points. They are usually marked right on the circuit board. (Take a look the next time you open the VCR.)

The VOM is quite versatile, while still being easy to use. Anyone capable of operating the controls of a VCR is also capable of making basic measurements with a VOM. Even if the measurements mean nothing to you, you can save time and money by having them handy for the technician. (This chapter will, however, help you to understand what they mean.)

USING THE VOM

Using a volt–ohmmeter isn't difficult. Actually, no home should be without one. It is one of the handiest tools anywhere for spotting a number of problems in a number of places. You can use it to check wall outlets, to check the wiring in your car, and of course to help you maintain and repair your VCR.

The two basic functions of the VOM are to read voltage and resistance. Ranges in each are accessed by a selector. How many ranges are available will depend on the cost and complexity of the meter.

Almost any meter will do for normal use. You don't have to spend hundreds of dollars on a fancy meter; the inexpensive $10 VOMs available will be accurate enough for your needs. (Of course, a better meter is to be preferred—

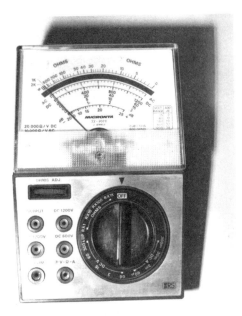

FIGURE 8-1 A basic VOM.

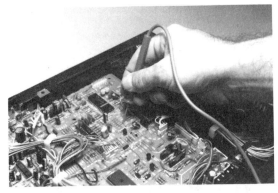

FIGURE 8-2 Always use care when probing inside the VCR.

especially if you'll be probing any sensitive components.)

Measuring Voltage

Voltage is measured as either AC (alternating current, such as what comes from the wall socket) or DC (direct current, such as the voltage from a battery or the power supply and is used in most electronic circuits). Most meters have several ranges in each.

Selecting the proper type and range is important. Try to read the 120 volts AC from the wall socket with the meter set to measure 3 volts DC and you're going to have some trouble. The same applies to having the selector set at 3 volts DC when a 93 volt DC pulse is coming in. A high voltage and a low setting can make the needle instantly swing across the face of the meter and wrap itself around the stop pin. Your meter would be ruined. It is always best to start with a range setting of higher than you think is necessary.

The probes have metal tips, which means they can conduct. Be extremely careful when you are poking around live circuits. It's easy to slip and create an accidental short. Even if the current isn't harmful to you, that short circuit can destroy the delicate components.

The best way is to *attach* the probes to the test points with the power off. (This assumes, of course, that your meter has probes with clips on them.) Double check that they are where they should be, then energize the circuit. Shut down the power again before removing or moving the probes.

For your own safety, try to clip at least the ground (black) probe. This way you'll be able to follow the "one hand rule." That is, you won't have to worry about holding both probes and can keep one of your hands in your pocket.

Measuring Resistance

The other function of the VOM is to measure resistance, which is done in units called ohms. This same function is used to measure for *lack* of resistance (continuity). How to use the meter to test cables for breaks and shorts is described in Chapter 5.

Testing Individual Components

The ohmmeter side of the VOM can also be used to test individual components. The method is much the same as testing cables. You're looking for certain resistances or lack of resistances. A diode, for example, conducts electricity in one direction only. In this direc-

FIGURE 8-3 Testing a component.

FIGURE 8-4 A polarity switch is handy.

tion there is a very low resistance to current. In the opposite direction, the resistance is extremely high. If you don't find this, you know that the diode needs to be replaced.

This particular test requires that you first test the diode with the probes one way and a second time with the probes reversed. Also, the DC voltages you'll be measuring can be either positive or negative with respect to ground. If you see the needle move down, in the wrong direction, all you have to do is to reverse the probes.

Some VOMs have a polarity switch, usually labeled "Forward" (or "Normal") and "Reverse." Having a polarity switch comes in very handy, especially if the probes are clipped into place. It also makes testing some components faster.

The two leads coming from the meter are usually black and red. Most of the time you'll be using the black probe as the *common* or ground (−) side, with the red (+) touching the spot being tested. The common side is either some marked or known spot, or the chassis itself.

The probes are insulated. This is there to protect you. Even when you are checking a

circuit with no power, make it a habit to hold or touch the probes *only* by the insulated handles. Sooner or later this habit will come in handy. Learn it early and you'll never have to learn the value of insulation the hard way.

THE POWER SUPPLY

The section of your machine which takes alternating current as supplied by a wall socket in your home and converts it into the direct current required for operation of VCR electronic circuits is the power supply. The 120 volts AC that comes into your home cannot be used as it is for very many things. It must first be changed to DC and to the needed voltages.

The power first goes to a transformer. This

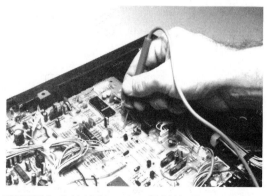

FIGURE 8-5 Hold the probes ONLY by the insulation.

The Electronics **73**

transformer takes the incoming 110 volts and steps it up or down to the values needed by the various electronic components of the set. Diodes are used to convert the AC to DC. This happens because a rectifier diode will allow current to pass in only one direction.

A single rectifier "throws away" half of the signal and thus isn't very efficient. By using several diodes connected in a special way (such as in a "bridge") the entire AC signal can pass through, but still comes out in only one direction.

A network of resistors and capacitors then filter the DC output by smoothing the sine wave of AC current to a nice steady DC flow. The easiest way to explain this is to show what the capacitor does.

As power is supplied to it, it "fills." So, when the rectifiers are feeding it power, such as during the positive portion of the AC cycle, it stores that power. During the other half of the cycle, the capacitor releases power into the circuits beyond, but does so *much* more smoothly than the 60 cycle AC being given to it. With proper circuit design, the DC coming from a power supply is very nearly as "clean" as the DC from a battery.

A regulator IC (integrated circuit, or "chip"), transistor, or some other section then takes over and maintains the output voltages at relatively constant values. If the circuit calls for 5 volts, for example, the regulator makes sure that it gets 5 volts and not 7 or 8 volts, even if the transformer or another earlier section of the power supply fails.

The power supply does just what the name says—it supplies power to everything else in the machine. If the power supply fails, so does the equipment. If a part of the power supply fails, the circuit that takes power from that part will also stop functioning.

CHECKING THE POWER SUPPLY

Before anything has gone wrong, you should have made a fairly thorough examination of the machine, including the circuit boards. Ideally you will already know where the various test points are located, have even used your VOM to take measurements at these points, and have written these findings down somewhere. (Room is provided for notes in the back of this book.)

Even with a schematic or service manual, you may find that the actual voltages at the test points are slightly different from those stated in the instructions (or written on the board). Certain tolerances are allowed. There is no need to be concerned about the variance, assuming the unit is functioning properly. The values are just fine.

WARNING
There is 120 volts AC coming to the power supply. This is potentially lethal. Proceed with caution!

The troubleshooting and testing procedure is fairly simple. It's nothing more than a process of elimination. The source of the problem can be in just so many places. Eliminate what is *not*

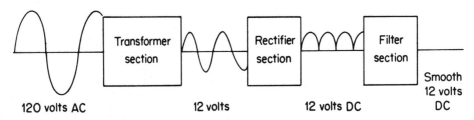

FIGURE 8–6 The function of a power supply. The drawing is overly simplified. The power supply of your VCR is more complex, but it works in the same way.

FIGURE 8–7 Check the wall outlet for incoming power.

causing the malfunction and you'll find what *is*. (Troubleshooting is covered more thoroughly in Chapter 9.)

The first step is to check out the obvious. Is the VCR plugged in? Is the outlet supplying power? Have you pressed the "power" button on your VCR? Don't take such simple things for granted.

A regular table lamp may be used to test the outlet, but this is an inaccurate gauge. The voltage coming from the outlet may actually be too low for operation of the VCR, but the lamp may still light. A meter will tell you exactly what the voltage is. If it's more than 15% out of range from 120 volts AC, chances are good that the power supply simply isn't able to keep up.

Next, open the cabinet and visually examine the inside. All of it, not *just* the power supply section. Pay special attention to any fuses or circuit breakers. If one has blown, unplug the machine and replace the fuse or reset the breaker. If it blows again, you have a short somewhere.

It's critical to know that bit of information. Chances are almost certain that you're safe, but it *could* be that there is a short between the incoming power and the chassis, in which case even touching the VCR while it's plugged in is potentially dangerous. (For this same reason, it's a good idea to unplug the machine even before you remove the case.)

Once you know it's safe to proceed, locate where the 120 AC comes into the VCR and to the power supply. If possible, clip the leads of the VOM to the spots before you plug in the VCR again.

Use your VOM to test for power across the fuse(s) and again as close to the power supply as possible. This is to find out if power is getting to the power supply.

Next test to see if power is coming *out* of the power supply. Because it's possible that something elsewhere is "dragging down" the power supply, it's best to unplug anything connected to it and test the power supply directly. If power is getting to the power supply but is not coming out, you have found the problem.

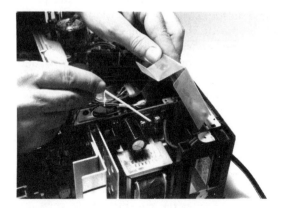

FIGURE 8–8 Examine and test the fuse.

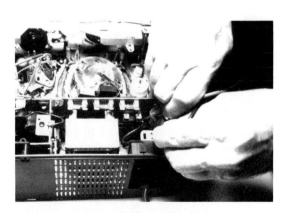

FIGURE 8–9 Test for incoming 120-AC.

The Electronics **75**

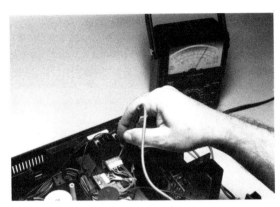

FIGURE 8-10 Test the power supply outputs.

Something is wrong in the power supply. Depending on your VCR, you may or may not be able to get inside for further testing and parts replacement.

If the power supply seems good and you still haven't found the problem, reconnect the power supply outputs, one by one, with the power off before making or breaking any connection. Try the VCR each time and test to see if power is still coming out. The moment it fails, you have a very good idea what section is causing the problem. Try connecting just that. If the power fails, you *know* you've found the problem.

TESTING BOARDS AND COMPONENTS

If you've tracked the malfunction to a particular circuit board, the easiest way to handle the problem is to replace that circuit board. This is just what most professionals do. The reason is because troubleshooting a circuit is often difficult and time consuming. At the rates charged for technical service, it can cost more to track the problem to a 5c resistor than to simply replace a $150 board. (For example, if it takes the technician 4 hours to track down that resistor as the part causing the trouble, and the service rate is $45 per hour, the charge to replace that 5c resistor will be $180.05.)

Of course, you aren't "charging" yourself. It might be worth your while to spend the time

to troubleshoot the suspected circuit board. How far you take it depends on your skills, knowledge, equipment, and time.

Visually examine the boards. Quite often a faulty component has obvious signs of damage. A resistor might be cracked; capacitors might show signs of fluid leaking from the inside. Also look carefully for leads that have come loose and for broken solder joints.

A customer was complaining about a constant shift of color in his television/VCR system. Through a process of elimination it was tracked to the color section of the TV (which let the VCR off the hook). One technician he hired was ready to yank out the color module boards and replace them. At $85 each these would have been a rather expensive way for the unwary owner to find out that the technician had never been taught to look things over first.

Then we looked it over. A transformer had one lead that was just barely in its socket, and no solder. Any little vibration caused the lead to break contact. Less than a penny's worth of solder cured the problem. All it took was a few minutes of visual inspection.

This visual inspection is always the first step in making a diagnosis or repair. Ignore it and you could waste a lot of time and money. Not only can it reveal that the malfunction is actually something very simple, it can help you spot a damaged component.

If you haven't already spotted the problem, consider carefully if you want to continue.

Some of the components may be effectively checked with nothing more than a VOM. Diodes, capacitors, many transistors, coils, and transformers may all be checked with the resistance or continuity scale on the meter. Be aware, however, that most of the circuit boards in the VCR are touchy. It's best that you limit most testing and all repairs on this level to the power supply. Leave the rest to the professional.

Most components can be checked with a VOM *only* when that component is disconnected or removed from the circuitry. While they are

still a part of the circuit, the readings you get are of the overall circuit, not of the suspected component. In the case of diodes, capacitors, coils, and resistors, the checks described below refect at least one end disconnected from the circuit.

This means unsoldering the lead—and another potential danger.

Resistors

The value of a resistor is written on it, either directly or more often as a color code. This code consists of bands of color on the outside of the resistor. Each color has a numerical value (see Table 8–1 and Fig. 8–13).

For example, if a resistor has bands of red, green, yellow, and gold, the value of that resistor is 250,000 ohms (usually called 250K, with the K meaning "thousand") and a tolerance of 5%. A resistor with bands of blue, gray, and brown would have a value of 680 ohms and a tolerance of 20% (because there is no color band).

TABLE 8–1 RESISTOR COLOR CODE

Color	Significant Figure	Decimal Multiplier
Black	0	1
Brown	1	10
Red	2	100
Orange	3	1000
Yellow	4	10,000
Green	5	100,000
Blue	6	1,000,000
Violet	7	10,000,000
Gray	8	100,000,000
White	9	1,000,000,000
Gold	—	0.1
Silver	—	0.01

FIGURE 8–11 Resistor color coding. A is the first significant figure; B is the second significant figure; C is the multiplier; D is the tolerance (with a gold band being 5%, silver being 10% and no color being 20%).

To test a resistor, one lead must be removed from the circuit. Set the ohmmeter to the proper scale and read the resistance on the meter. It should be within the tolerance range allowed. That is, if the tolerance band is gold, it should be within 5% of the coded value.

Diodes and Transistors

The value, type, and code number are usually written on the case of the component. From this the technician can look it up in a table to find out what the component is doing.

Due to its nature, a diode allows current to flow easily in one direction and not in the other. Put the range selector of the VOM on a high resistance scale. Attach a probe to each end of the diode. Some resistance value will be indicated. Now, reverse the probes, and the value should be considerably different—at least 2:1. In other words, the diode should have higher resistance in one direction than in the other. If there is no difference in the two readings, or if the meter indicates no resistance (a dead short) the diode is bad.

Transistors must be removed from the circuit for a resistance check. It's possible to check the transistor with a VOM for operating voltage while it remains in the circuit. Otherwise, and better yet, you'll need an in-circuit transistor checking device.

Transistors can be considered to be similar to two diodes connected back to back. This makes it possible to check most transistors with the resistance scale of the VOM.

There are 3 leads to a transistor, called the emitter, the collector, and the base. (See Fig.

FIGURE 8–12 Testing a transistor.

When it is inconvenient (or impossible) to remove a transistor from a circuit for thorough testing, some DC voltage measurements can be made while the transistor is still in the circuit. The power must be one for this test, which means that the test has with it a degree of danger.

For most basic amplifier and voltage regulator circuits, the voltage should be somewhere from .15 to .7 volts directly between the emitter and the base. (You can also measure the voltage between emitter and ground, then between base and ground, and subtract the two—if you want to get complicated about it.)

If you determine that the voltage is present, the next step is to determine if you have collector current. This can be determined by making a voltage measurement from collector to ground. If there is no voltage, the transistor is probably bad (or that transistor is being used in a different way than usual). The only absolute check requires that you use a transistor checker or remove the transistor from the circuit.

It's always important when you are using the probes of the meter to avoid short circuiting any points on the circuit boards. Not only will your measurements be useless, you can cause severe damage to the entire unit. It's best to always shut down the power to the unit when you are connecting or disconnecting the test leads just in case you slip.

Because it's easy to cause extensive damage, it's generally best to leave any circuit board or component testing (beyond your visual examination and a VOM) to the professional.

8–13.) Put the VOM probes on the leads between the emitter and base and note the resistance reading on the meter. Reverse the leads (or throw the polarity switch). The indication should be the same as for a diode—high resistance one way, low the other. If the two values are nearly the same or you have no resistance, the transistor is bad.

Similarly, the leads can be used to check the continuity between the collector and base of the transistor. Again you should get a high resistance in one direction and a low resistance in the other.

Normally, there should be a high resistance value both directions when the ohmmeter leads are placed between the collector and the emitter.

Replacement

If you manage to locate the single component that is causing the problem, it's normally fairly simple to make the repair. This is done by replacing the bad component with a new part. Although you should be extremely wary of fiddling with most of the other circuit boards, making component replacement on the less sensitive boards and sections, such as the power supply, are easily within your capability.

FIGURE 8–13 The three leads of a typical transistor.

You don't have to be a trained electronics expert to replace a bad diode or transistor. Most components are plainly marked as to their value. Resistors, for example, have colored bands that tell you how many ohms that resistor provides, the percent of tolerance, and even how much power it will handle. Transistors, diodes, and other components will usually have a label with letters and numbers (such as "1N914"). This will tell you exactly what is needed for replacement.

Be warned that if you replace a bad component and the new one blows as well, the actual cause of the malfunction could be elsewhere in the circuit. You have a choice at this point. You can replace that component again, assuming that the first replacement happened to be bad as well. You can spend some time trying to find what the *real* problem is or take the unit to a professional to solve.

If you know nothing about how to identify components or how to read component values, it would be a good idea to get a book on basic electronics. You could also take the bad part to an electronics supply store to identify and provide a replacement.

Any replacement has to be an *exact* match to the one removed. The wrong one simply won't work. It can even cause damage to other circuits and parts.

As mentioned in Chapter 2, soldering is an art. It's not just a matter of sticking a hot piece of metal in there and letting it melt the solder. Spend some time learning how to solder correctly. The time to learn and experiment is *not* while working inside your VCR.

Adjustments

On some circuit boards you'll find tiny boxes with screws in them that have words along side such as " +5 Adjust." If the unit is operating fine, leave these alone. If your meter indicates that the power coming into a board is incorrect, you can try to bring it to the correct value by carefully turning the screw on these "pots." (A "pot" is an adjustable variable resistor.)

WARNING

DO NOT attempt to adjust any screw or device that is labeled "Bias" or *anything* other than "voltage." The adjustment on these requires equipment much more sensitive and complex than a VOM.

SUMMARY

Testing and replacing the electronic components of your VCR is a critical step. Many of the circuits are extremely delicate. One mistake, and there goes a whole circuit board. *Don't tackle the job unless you feel confident and know that you can be careful!*

A volt-ohmmeter is easy to use and can let you perform quite a few tests. Its two most important tests are to find out if the power supply is providing the correct voltage to the boards and to find out if certain components have become bad (by testing for resistance and continuity).

It's not a bad idea to make these voltage measurements when the machine is operating properly even if you have a service manual. Jot down the results of this inspection.

Diagnosis is a matter of elimination and isolation. Using the meter and some common sense you can eliminate quite a few things that are *not* causing the problem. Given time, this will point to exactly what *is* at fault.

Most of the time you'll only be dealing with the power supply or with the rest of the VCR on a circuit board level. Testing individual components is difficult and brings a fairly high degree of danger.

Your tests should let you know quickly if the power supply is bad or which circuit board has gone down. Repair is most often done by replacement of the entire unit or board. (That's what they'd do in the shop, for $35–$60 an hour, plus parts.)

If you manage to track the problem to a single component, that component can often be replaced. Avoid doing this except in the power

supply. Never replace a part with something that isn't an exact match and be VERY careful when soldering or desoldering. Don't do any of this until you've thoroughly examined the circuits visually. (Look for the obvious.)

Testing and adjusting of the complex circuits requires the use of complex equipment. These tasks are best left to the professional technician no matter how confident you feel.

(Unless of course you are a competent technician and familiar with this test equipment.)

Sometimes a malfunction can be fixed by merely making an adjustment. Some of these adjustments can be made with nothing more than a screwdriver (insulated) and a VOM. If the correct value isn't printed on the circuit board next to the adjustment, refer to the service manual for your particular make and model.

Chapter 9

Troubleshooting Guide

Troubleshooting even fairly complicated problems isn't difficult if you use your common sense and the step-by-step process that professionals use. Even without any technical background at all, you can have success that will surprise you.

The real trick is to realize that you *can* do it! If you let the equipment intimidate you, you've cut your chances in half before you even begin. As long as you exercise proper caution, and know your limits, you can proceed with confidence.

The first steps in virtually every case of troubleshooting begins outside the equipment. Eventually you might find yourself inside and perhaps even poking around with the probes of test equipment (particularly the VOM) but this is a last resort. The farther you take it, the greater the risks of causing damage to the VCR or to yourself.

GETTING SOME BACKGROUND

Although you don't need to be a trained technician to handle most troubleshooting, the more technical background you have, the easier things will be. (In other words, there's no substitute for experience.)

A good place to start learning how to troubleshoot is to pick up a good book on basic electronics. You don't have to be an electronics engineer, but gaining a basic understanding of what the components are doing, and how, can really help.

In the same way, a bit of knowledge of physical mechanisms won't hurt. Much of this can be figured out by common sense. As an example, a large pulley is driving a smaller one with a belt as the connection between the two. The smaller pulley will be spinning faster. (If the circumference (the distance around) of the larger is 3 times the smaller, the smaller one will have to spin 3 times as quickly.) If the belt between the two slips or breaks, the smaller pulley can't move properly (if at all). It's as simple as that.

Although all VCRs work similarly, each make and model has its own peculiarities. Each machine design has certain design peculiarities—certain manufacturing weaknesses (and strengths). For example, a certain guide pin in your particular machine might be prone to bending or a certain capacitor in the power supply might be known to give out at 6-month intervals.

Often, something that breaks down once

will do so again. It might take you some time to figure out all the quirks of your machine in this respect and to learn what sorts of things to look for first inside. It will help if you keep close track of what goes wrong, such as by keeping an accurate record of it in the Owner's Log and Owner's Notes at the end of this book. This could reveal a pattern.

TROUBLESHOOTING STEPS

At the end of this chapter is a troubleshooting chart which gives you some of the most common malfunctions, their causes, and what to do about them. (Your owner's manual and service manual may have others that apply just to your make and model.) This is a good starting point, but such lists are necessarily brief. It would be impossible to make a list of *all* the possibilities. If you can't find the answer to your question there, you have to rely on yourself.

Even with a troubleshooting chart available, try to find the source of the problem, and the cure, on your own. Once again, there is no substitute for experience. Each time you get the opportunity to practice troubleshooting techniques, you'll get better. This will help to "hone" your skills for the day you really need them.

Don't pass up the chance to practice on things other than your VCR. Troubleshooting techniques are always the same, whether the problem be in your VCR, toaster, or lawn mower. Every time you track down and fix a malfunction, you've increased your ability to handle more complicated situations.

Here are the 7 basic steps in troubleshooting.

1. Check for the obvious
2. Check for operator error (YOU!)
3. Check for cassette problems
4. Check for mechanical problems
5. Test the electronics
6. Use process of elimination and isolation

7. Get professional help (if the job is beyond you)

Check the Obvious

A classic story tells of a major freeway that was blocked by a large truck. The truck came to an overpass, but the bridge was too low for the truck to clear. The top of the semi was 4″ too high. The driver studied the problem; the sheriffs studied the problem; transportation experts came out and studied the problem. Calculations were made on how long it would take to remove a section of the bridge or to cut away the top of the truck. It seemed that the only sensible solution was to get all the traffic behind the truck off the freeway. This meant that several miles of vehicles would have to drive in reverse, go backwards up the on-ramps and try to disperse while new traffic kept pressing in.

A young boy was stuck there with his father and was enjoying the whole scene. As anxious as he was to watch a chunk of bridge removed, he couldn't help making a suggestion. "Why not let some air out of the tires, drive under, and put the air back in?"

Most of the time you'll find that the problem isn't a problem at all. Something simple has gone wrong. Perhaps a bug has become caught in the mechanism and is preventing it from moving. A belt might be broken or is slipping.

Even more serious malfunctions can often be spotted by merely looking. Electrolytic capacitors, for example, have the tendency to leak when they go bad. The stains running down the sides of the capacitor and onto the circuit board are easy to spot, if you just look for them.

The first step in proper diagnosis of an unknown problem is the visual check. This begins outside the cabinet. Is the unit plugged in? Is the wall outlet good? Are all the cables and external connections in the proper places, and are all those wires good? Is the problem outside the VCR—perhaps with the television or monitor? Don't think that just because a possibility sounds silly that it can be ignored.

If you haven't found the problem and decide to go inside the cabinet, once again begin by looking for the obvious. What appears to be a serious malfunction could be nothing more than a broken or loose wire. A fuse may have blown. Bad components can often be spotted quickly. (If you find a burned component, don't forget to take the obvious step of wondering *why* that happened.)

By looking for the obvious you could find that the actual cause is quite different from what *seems* to be wrong. This in itself can save you a lot of time and frustration.

Check for Operator Error

In a way, this should be a part of "Check the Obvious." So many problems are due to something the operator does (or doesn't do) somewhere along the line. It doesn't concern just those operators who are new to video either. Those who have been around for years (like the transportation experts above) make mistakes or overlook certain things. Even if you've been using the same VCR for the past 5 years and feel certain you know what you're doing with it, you *can* make mistakes.

A tape not loading could be something as simple as having the cassette upside-down. (Sounds silly, but it *does* happen.) A dubbing problem could be nothing more than having the cables connected incorrectly.

Read through the operator's manual that came with your VCR. Learn how the various things on it function. Before you start blaming the machine, be sure that you're not trying to get it to do something that it can't do.

Check for Cassette Problems

One of the weakest points of the VCR is the cassette. The tape can get itself mangled up inside the machine, not because there is necessarily anything wrong with the VCR. That particular tape could be the cause of the problem.

Tape can break, twist, stretch, bind, or crinkle. The case mechanisms can cause so many problems that you'll swear that they were specifically designed to fall apart or otherwise ruin your viewing—if not your VCR. Beyond all this, the coating on the tape will eventually break down, flake, and otherwise cause early baldness (from your yanking out your hair in frustration).

Many malfunctions that appear to be a problem with the machine are actually nothing more than a bad tape, a bad case, or both. A flickering or twisted picture, for example, might give you the idea that one or more of the circuits is giving out, especially if the tracking control doesn't seem to fix it. Tearing the VCR apart or taking it to the shop may be a mistake. The cause is much more likely to be a flaw in the tape, either during manufacture of through heavy use.

It's easy to check this. If you are having a problem that could even *possibly* be caused by the tape, all you have to do is to try another tape. It's possible that two tapes will show the same symptoms, especially if they've been stored under the same conditions. If you suspect that the two tapes might have the same kind of flaw, try a third or even a fourth.

There is an exception to this. If the tape is physically damaged the problem is more likely to be in the VCR. In this case DON'T try another tape unless it's something you can afford to waste. You'll only be ruining more cassettes and will be taking the chance of further damaging the machine.

If you're going to test the VCR this way, run the test tape forward a little way, then set the counter to zero. Eject the tape and open the door to examine the tape. Be sure that it's perfectly flat. Re-insert the tape and start "Play" or "Record." Let it go for perhaps a minute. Eject, open the door and examine the tape again to see if there are any crinkles. If not, back it up to the zero point, eject, and examine the tape again.

If you suspect the tape(s) but can't seem

FIGURE 9-1 Open the cassette's door and examine the tape for damage, especially to the sync track.

to find the problem, refer to Chapter 6 in this book for more information on cassettes.

Before we leave this subject, one of the best investments you can make is to "waste" a tape by making a recording that will never be viewed except when there is a problem.

Make sure that your machine is in perfect working order, such as when it's new. Put in a new cassette you know to be good and make a recording. Play it back to be sure that the recording quality is good. Then put the tape back in its box, label it "Alignment Tape," and store it in a safe place. Then every few months watch a portion. If you notice a degradation in what was once a "perfect" recording, you know that something is wrong.

Check for Mechanical Problems

A close second to cassettes as a leading cause of trouble are the mechanical parts of the VCR. Anything mechanical—in a VCR or anywhere else—is subject to wear, no matter how well it's made and no matter how well you take care of it. The more complex the device, the more often it will present problems.

The more dust, dirt, and contaminants there are on the moving parts, the more quickly those parts will malfunction or fail. Making matters worse, all those things are going to be carried deeper into the VCR where they'll eventually affect everything. By keeping everything as clean as possible you'll greatly reduce the malfunctions (see Chapter 7).

During each cleaning, and any time you have the chance, inspect all moving parts for wear. The rollers may have developed flat spots. Quite often this is caused by the rollers failing to rotate correctly on the spindles. It's rarely a good idea to attempt to lubricate the spindles, as even the tiniest drop of oil can permanently contaminate that roller which will in turn contaminate any tape you use in the machine, and then get down inside the machine, causing more and more damage.

Repair of worn or damaged parts is usually by replacement. Sometimes a bent part can be straightened, but attempt this only if you know what you are doing. You should have a service manual close at hand before beginning, as this will help guide you and will show you things

that are specific to your machine. Proceed slowly and carefully. You can cause a lot of damage by being in a hurry.

Test the Electronics

Chapter 8 told you how to test the power supply, the circuit boards, and the electronic components. This isn't difficult to do until you get to the component level. The results of the tests will usually point to the cause of the problem if it is electronic in nature. (The next section shows you how.)

The testing detailed in this book is necessarily basic. The specifics you need will be found printed on the circuit boards and in the service manual for your unit.

Keep in mind that even though the tests are simple, there are dangers involved. The 120 volts AC is the most dangerous thing as far as you are concerned. Fortunately, there aren't many "hot spots" inside the VCR. However, there are a number of places where a slight error on your part can cause instant and expensive damage.

Before you do anything, read Chapter 2 again on safety precautions. Always remember the single best rule: "There is no such thing as being *too* safe."

Use Process of Elimination and Isolation

As you perform all of the above steps you'll be getting closer and closer to the cause of the trouble by eliminating those things that are not and thus isolating it to those things that might be.

As an example, assume that nothing happens when you flip on the power. The fault is only one of two places—inside or outside. By checking the wall outlet you know that power is available. Checking the power cord and any external fuse(s) will tell you if power is getting to the VCR.

This sounds almost too simple. Yet with just that one step you've eliminated either the VCR or the entire outside world. In a matter of seconds you've narrowed the possibilities

greatly. Continue this and you will eventually find what is causing the problem, by narrowing the possibilities tighter and tighter.

Once inside you check any internal fuse(s) and the switch. If both are good, then the problem is either in the power supply, in one of the circuit boards, or in the wiring between them.

A visual check will usually eliminate the possibility of the wiring being at fault, which now leaves only the power supply or the circuit boards.

Out comes the VOM. By following the steps given in Chapter 8 (test for incoming power, test for outgoing power) you'll find out if the power supply is functioning properly or not. If it isn't producing the needed voltages, you've isolated the malfunction to the power supply section. You can either replace it or troubleshoot to the component level. If it *is* supplying all the proper voltages, you'll still know where the problem is because the tests will show you which circuit board is causing the power supply to drag down.

Once you've eliminated all the sections that are *not* at fault, you can concentrate on the bad section. A visual check may reveal that a particular component is obviously damaged. A schematic of the section will help you to track down a faulty part that doesn't show. Again, you're eliminating the good things, one by one, until only the bad is left.

If you don't feel confident that you can find a malfunction on the component level, you'll still have saved a great deal of time and money. Instead of bringing in a malfunctioning unit with an, "It's broke—fix it!", you'll be able to say, "The power supply regulator board is acting up."

Many of the electronic repairs, especially those outside the power supply, will be handled by simply swapping a board. Even if you have a technician do the actual swapping, being able to tell them exactly which board has failed will turn the job from an expensive risk to a quick inexpensive (relatively) swap.

Get Professional Help

As just mentioned, there will come a time when your own efforts should be stopped and the job turned over to a professional. Don't continue fiddling around once you've reached the edge of your competency and knowledge.

There are certain things that the owner should never attempt. If your diagnosis shows that the heads need replacement, it's time to bring the VCR into the shop. It's also wise to leave all repairs of circuits boards (except the power supply) to a professional. Some of these are quite touchy.

Attempting to do a job when you lack the skill, knowledge, and equipment is likely to make things worse. Instead of saving time and money, you'll be wasting both.

TROUBLESHOOTING CHART

SYMPTOM	CAUSE	WHAT TO DO
Nothing happens	No power	Check outlet and cord
		Check fuse
		Check power supply
No video, or no audio	Blank tape	Try another tape
	Bad connections	Check cables and connectors
	Dirty or bad heads	Clean or replace
	Bad speaker (audio)	Replace
	Bad circuit board	Replace
	TV adjustments off	Adjust or fix
No color	Tracking is off	Adjust
	Television isn't adjusted.	Adjust
	Dirty heads	Clean
	Bad color board	Adjust or replace
Wiggly picture	Tracking is off	Adjust
	Dirty heads	Clean
	Dirty transport	Clean
	Tension off	Adjust
	Bad tape	Try another
	Horizontal control bad	Adjust or replace
	Servo problems	Adjust or replace
Excessive Dropouts	Bad tape	Try another; buy better
	Dirty head	Clean
	Tracking is off	Adjust
	Dirty tuner	Clean or replace
No recording	No input	Check cables and connectors
		Check instructions
	Stuck relay	Try "Record" several times

Poor recording	Poor input	Check and correct
	Dirty heads	Clean
	Bad erase head	Check and/or replace
	Bad tape	Replace—buy better!
Playback but no Record	No signal	Check antenna or cable or related parts
	Dirty head	Clean
	Misaligned head	Align
Faulty playback, no playback, tape won't load	Belts	Check, replace if needed
	Bad tape or case	Try another—buy better!
No capstan, roller, head or motor motion	Power	Check wall outlet, cord, fuse, power supply
Switch malfunction	Bad switch	Replace
	Bad linkage	Replace
Tape binding or sticking	Bad tape	Try another—buy better
	Transport trouble	Clean, visually check, replace worn parts
	Excessive moisture	Keep it dry!

Chapter 10

When You Need Professional Help

No matter how well you maintain your VCR or how much you learn about repairing it, there will be times when you will have no choice but to call in a professional (and pay those professional fees!). It can't be helped. Certain repairs demand the use of special (and expensive) equipment. Others require special knowledge that is far beyond the scope of any single book.

This book is meant to reduce to a minimum those times when you have to hire a professional and to cut the amount you'll have to spend when those times occur. When you have to consult a professional you'll have already taken care of many of the steps of diagnosis and can supply a great deal of information to the technician. Because you've spent the time, he or she doesn't have to (and you don't have to pay for the time.)

FINDING A TECHNICIAN

It is often difficult and frustrating trying to find a reliable technician in *any* field. This isn't to say that there aren't plenty of competent and honest repair people or that you should automatically suspect every one of them. Just be cautious and don't accept everything you're told.

There are very few shops that can handle all kinds of repairs on all kinds of VCRs. More than once this book has made note of the fact that there are hundreds of differences even between machines manufactured by the same company. Nobody can be expected to know everything. (If they tell you that they do, find someone else—quick!) There are many things that are the same, regardless of the machine, that any competent technician can handle; but to do something more complex (such as aligning the heads), the technician *should* have experience specific to the make and model you own.

There are no federal regulations governing electronics repair. No licensing is needed except when the technician is working on transmitters. However, most states have some form of industry self–regulation. Certification such as Certified Electronics Technician (CET) exams, isn't necessary to open a shop, but it *does* tend to make competency a little more standard.

This is a written exam, not a hands–on you-really-fix-that-machine test. All it says is that the person has (or had) enough technical information to pass the exam. It says nothing

about manual ability or the honesty and integrity of the shop.

Common sense precautions in finding a good electronics technician are the same as used in getting a qualified auto mechanic or even a doctor. Don't hire just anyone. Check with friends or even with strangers who own VCRs like yours. (And if you find a GOOD technician share that information with other people.) The best recommendations will come from consumers not from the sales staff of a store that has a service bay in the back.

Lacking these resources, try to talk with the person who will be working on your machine. A typical trick is for the front counter to keep customers away from the service personnel, both in person and over the phone. A part of the reason for this is to allow the service department to do their job. The more time they spend talking, the less time they'll spend on work. This could also be an indication that getting satisfaction will be difficult with that particular shop. Your decision on this will be based on how the people you talk to handle things.

Talking to the actual serviceperson will provide you with a fair indication of that individual's competence and attitude. You've learned enough from reading this book, and by performing the tests and steps covered, to go in knowing at least a little something. This will work as a rough guide of the technician's knowledge. Don't be afraid to ask if he or she has had experience on a machine like yours, especially if the job is touchy.

A serviceperson who is rude or who refuses to talk about what will be required for the repair should be a large red danger signal. If this is the attitude *before* payment, imagine what things will be like if your check has already been cashed but the problem still exists. Servicepeople that don't care enough to show you their "good side" to get your business are likely to be even worse when it comes to handling a complaint.

Price alone is not a good base for picking a serviceperson or shop. The apparent costs can be misleading in both directions. High charges don't necessarily mean high quality. At the same time, someone who charges "economy rates" could wind up being extremely expensive.

As with so many "bargains," the low cost could be an indication of a lack of competence or slowness getting the job done. Not only could an incompetent technician cause costly damage to the machine, there is the matter of time. Imagine a low priced but inexperienced person who charges $10 an hour for his services, and spends 4 hours on a job. A technician charging $35 an hour might be able to get the job done in less than an hour. So, even though he charges more, he charges less.

Luck is part of it. You could stumble into the first shop you see in the *Yellow Pages* or down the street and accidentally find the best person in town for the job. You could also find the worst, or someone who will charge you for repairs that were not necessary, and even one who will claim to replace parts that actually have not been touched.

Once you find a reliable trustworthy technician, hang on! Let the individual know how you appreciate the good service, both verbally so and by referring customers. You might even offer to let prospective customers call you for verification.

TERMS FOR REPAIR

There are several things you can do to help keep things honest. Again, most of it is common sense.

1. Get a warranty that the work will be done to your satisfaction. A $40 bargain repair is useless if the serviceperson won't stand behind the work.
2. Get a warranty of *at least* 30 days on both parts and labor. (Obviously, the warranty will only cover the work done. If you've had the heads aligned and a week later the power supply gives out, the warranty will not cover that.) Having the warranty in writing is important.

3. Get everything in writing, including the cost estimate for the repair. This estimate might be slightly different from the actual cost, but if the difference is major you most likely have legal recourse. (To further protect yourself, have it written on the estimate that the cost is NOT to exceed a particular amount without your permission.) Along with the quoted price, the estimate sheet should say exactly what is to be done, when it is to be done, when you can expect to get the unit back, and state clearly the terms warranty.

4. When the work is complete, ask for an itemized list of what was done and what the cost was for each thing. (You can jot this information down in the space provided at the end of this book.) This is your protection for any warranty service and is also a good thing to have around for future reference. To avoid complications it would be a good idea to specify your request for the itemized list before the work begins. Some shops automatically keep an itemized list; others do not.

5. Before they do *anything*, let them know that you want all parts that have been replaced. This won't do much good if you've never opened your unit and have never checked to see what is there. But, if you've given them the idea that you know what all is inside, they will be much less likely to try to tell you that a burned out Sony video head came from your Hitachi machine. (It's a good idea to keep the old part around. Next time you open the machine, find the new part. It will be the one that looks newer and will usually have signs of new work around it.)

If the shop refuses to give all this to you, go elsewhere. The only exception is when a circuit board is to be swapped out. It's possible that the old board has some trade–in value. There are companies that have the equipment to refurbish certain circuit boards. In essence, they buy malfunctioning boards, diagnose them, fix them, and sell them to shops for a rate lower than a new circuit board, but usually with the same warranty as new.

If that circuit board has a trade–in value and *you* want it, you'll end up paying for it, one way or another.

Before turning over the equipment be sure that the technician knows as much as possible about the problem. Does he understand what is wrong and what the symptoms are? If not, he may not know where to begin or what to look for. The more information you can provide, the better. If you've done your "homework" properly, you'll have already written down this information for yourself. Provide a copy for the technician. Having this information in writing is much better than having it verbal only.

RESPONSIBILITIES OF THE DEALER

When the dealer sells you equipment, he or she assumes a certain amount of responsibility. (If he doesn't do this automatically, you should probably find another dealer.) This begins with the dealer making sure that the VCR is functioning when you get it. If you buy an entire system, the dealer should see to it that everything functions as a unit before turning it over to you. It should *not* be handed over as nothing more than a pile of boxes. If the dealer operates this way, you might as well go through a mail order company and save some money. Don't be afraid to ask the dealer to put in writing the promises made for the support of the products you buy or to show you where the dealer's responsibilities to you are specified in the printed warranty material that comes with the equipment. Know where you stand and what your options are.

I bought a new VCR not long ago. It was on sale and was just the addition I needed for my system. Although I had no need of technical help to know how to make the connections, my curiosity got the better of me. I explained what I had in mind (multiple television hookup) and asked, "How do I connect everything?" The

salesman got out a piece of paper and drew sketches of two ways I could cable that particular scheme. He then made sure that I had everything needed, and that I understood his instructions. Finally, he wrote his name and phone number on that slip of paper.

Needless to say, he not only made the sale, but is someone I use as a recommendation of a great place to make a purchase. He showed that important sense of responsibility to the customer. I didn't need the information he gave me—but he didn't know that.

After purchase of the equipment, the dealer continues to have the responsibility of customer care. If you have a problem a few weeks or months after getting the VCR home, you should feel welcome to call in with questions. This includes both technical questions involving basic operation of the equipment purchased and repair when something goes wrong. Service during the warranty period is obvious. The service should continue beyond this period (within reason), however, especially as it concerns answering questions.

Some dealers work on a smaller basis, or as a department store, and do not keep a technical staff in the shop. They can't afford to. If this is the case, the dealer should at least be able to guide you to the proper people for your needs or to find the answers to your questions. Being small (or large) is no excuse for being unable to provide customer service when it is needed. It is the responsibility of dealers of any size and something you should look for when finding the dealer to do business with.

Manufacturers are famous for refusing to talk to the end user. It is usually assumed by them to be the responsibility of the person who sold you the item. Thus, even if he or she doesn't want it, the responsibility falls on the dealer to provide the needed services for the customers.

YOUR RESPONSIBILITIES

If you expect assistance or information from a local dealer you should begin by giving that person some business. Keep in mind why the dealer is there—to earn a living—hopefully a fairly nice one. The profits aren't nearly as high as you might think.

The dealer is *not* there to provide an easy source of free advice or free services. The technical staff kept available to handle questions, problems, and repairs costs the dealer money. There are salaries to pay, equipment to buy and maintain plus lots of other expenses. When the staff is doing a repair job, they are earning their keep, and the store is making money. When they're handing out free information and telling you how to fix your own machine, they're doing exactly the opposite.

Even if you didn't purchase your system from a particular dealer, you can build a working relationship by giving him or her your other business. Keep in mind that it works both ways. Be fair with the dealer and your dealer is more likely to be fair with you. Obviously, there is no sense in buying things you don't need. But when you *do* need something, and if the dealer has gone out of his way to be helpful, show him your appreciation by doing business with him.

With the information in this book you should be able to provide a considerable amount of information to the technician. Your goals are to reduce the cost of repair and the amount of time that repair will take. You'll be gaining a secondary benefit in that you'll be letting the technical staff know that you have some idea of what you're talking about.

Before even calling, try to find out if the malfunction has been caused by operator error. It's unfortunate but true that the technician has probably become accustomed to starting off wondering if the customer has even bothered to read the instruction manual. There are hundreds of humorous, but true, stories of people turning a "broken" machine over to a technician, when the only problem is that it wasn't plugged in.

Also try to gather as much other information as you can. The more accurate infor-

mation you provide, the easier will be the job of the technician. To you this means increased efficiency, lower cost and less down time with your VCR sitting on the testing bench.

Having some idea of what is going on can provide better service. If the technicians (and the shop) are honest and reliable just the idea that they're dealing with someone with intelligence will help. If they happen to be one of the very few dishonest shops around, the fact that you know a little something can deter them from trying to "pull a fast one."

A fair part of the technician's day is simply guiding the customer through the right questions. When the customer calls in with a "Why is it broken?" query, the technician spends some time getting the customer to answer the right questions (and to get the customer to ask a few pertinent questions). The technician recognizes that the customer who knows what things to look for is rare.

Don't be afraid to make suggestions or helpful comments (but at the same time don't pretend to have more technical expertise than the repair person). It's possible that you know something special about the circumstances. If you've gathered information (such as put together from the tests, etc. you've performed from this book), provide that information. Anything that makes the technician's job easier will be (or should be) appreciated. It should also help to reduce the amount you pay for the technical work.

Use common sense. The technician, the manager, and the dealer are people. Treat them with respect and you'll get much more accomplished. Common sense and courtesy are your two greatest tools for dealing with others. Apply the "Golden Rule" and you'll get more done, faster.

SOLVING PROBLEMS

No matter how good the technician is, or how reputable the company is, there will be times when problems will arise. Many could have been prevented if communications between you and the shop were carried on properly to begin with. Others result from unforeseen malfunctions. Or perhaps one of the parts installed is faulty. Occasionally a mistake will have been made during repair.

If the work is not done to your satisfaction, say so. But again keep in mind that you're dealing with people. The nastier you are, the less willing they'll be to take care of the problem. That's only human nature. (You'd react the same way.)

Talk to the technician who did the work first. Chances are good that the problem is something the technician can handle; if not, go to the service manager, and then to the general manager. It might take a little longer to go through the "chain of command" but the end results are often better.

THE SERVICE MANUAL

It is the policy of manufacturers not to list routine maintenance schedules and precautions in the operators manual that comes with the VCR. It appears to be the policy of most makers of electronic equipment to try to encourage the buyer to purchase a service contract from that company's dealer at the time of original purchase, or of making sure that maintenance is handled by the dealer. Those owners who don't have the dealer do the work, and don't know how to do it themselves, make the manufacturers happy, too, because the machine won't last very long before a new one has to be purchased.

The routine maintenance steps necessary for keeping the machine in peak performance condition are described in more detail in the service manuals which are put together for every make and model of VCR made. However, these manuals do not go to the owner. In fact, most end users don't even know that such manuals exist.

The basic maintenance steps given in Chapter 7 of this book hold true for all machines. However, it is important to get a copy of the service manual for your unit. This will tell you about things specific to your make and model.

Sometimes these manuals are available only to manufacturer–recognized service personnel. Most of the time, the dealer is perfectly willing to order a copy for your use. All you have to do is to ask for it—and be willing to pay the price. (Cost of the service manual is usually between $20 and $35.)

SUMMARY

You have to decide whether or not you can handle a repair job that comes up. The number of times this situation comes up can be greatly reduced by proper and regular maintenance, but it *will* come up eventually. If you have doubts, you might be better off going with a local dealer or repair shop.

Both the dealer and you have responsibilities. It's a two-way street—or should be. The dealer owes to the customers all the necessary support for whatever is being sold and should be willing to stand behind the products carried. The staff should be competent enough to give sensible advice as to which products will best suit your needs.

Verbal communication is one of the things to look for when finding a serviceperson. If technicians aren't willing to talk to you before the job is done, they are even less likely to be willing to talk to a dissatisfied customer.

Everything must be in writing before you leave the machine. Once servicepeople have it, the only way you'll get it back is to pay the price they want or resort to the courts (which will probably cost *at least* as much as the repair.) This written agreement will state what is wrong, how much it will cost for the repair, the maximum you are willing to pay if the estimate is incorrect, the time required and any other conditions stipulated. One of those stipulations you should make is that parts that are replaced are to be returned to you. This is your legal right and is good protection. An honest shop or technician will not take offense. Know your rights and options. Then use common sense. Usually it's as simple as that.

Before buying the VCR you want, check to see if there is a service manual available for it. This won't be as important to you if you plan to carry out just simple routine maintenance, but it is important regardless. The extra $25 or so is a good investment.

A part of the deal you make with dealers when buying a VCR is to have them show you how the cover is removed. Most owners never remove this cover, and resort to a cleaning cassette for all maintenance. As you already know, this is just a temporary measure. If you want to save money and keep your VCR in top condition, you'll have to remove that cover on a regular basis; this is the *only* way to reliably maintain the machine.

Chapter 11

Camcorders and Other Video Equipment

When I was a young teen, a new wonder came to a local department store and was put on display. It was the first video tape recorder available for the homeowner. It weighed close to 90 pounds, used large and expensive reels of tape, could record and playback in black & white only, and cost about $5000 for the deck and another $4000 for the camera.

Not only was the price a problem, the unit had the tendency to require technical adjustments on a regular basis and finding a technician to handle the job was nearly impossible.

Things have changed. VCRs today are reliable and relatively inexpensive. The improvements have made it possible to build in better quality packed in a smaller size. The advances have also made it possible to buy equipment that didn't even exist a few years ago.

When those first home VTRs were made available, the video cameras were capable of monochrome only and that was of marginal quality. As quality on home video cameras improved, prices dropped. But for a long time the only way you could take the camera into the yard was if you had a portable video deck.

A majority of homes now have VCRs and a growing number have camcorders, which is a video camera and VCR in one package. (Circuitry had improved to the point that the battery needed to power a camcorder is lightweight.) Along with this has come a variety of peripheral equipment capable of doing things that formerly required a professional studio to produce.

As is so often the case, with the flood of advances comes confusion. The newcomer has to learn all the terminology to even *hope* to make an intelligent decision. Even after learning the appropriate words, the number of choices can be overwhelming.

Note: *For more details on home video equipment, including many operating tips, see "Chilton's Guide to Using and Maintaining Home Video Cameras and Equipment," also by Gene B. Williams.*

CAMCORDERS

As with VCRs, the shift has been toward VHS as the most available format. This means that you have the broadest choice of manufac-

turers, styles, and even prices with that format. It doesn't mean that other formats aren't available.

Format will be one of your first choices. With some exceptions, it's better to go with the same format you have in the home deck. The reason is that the tapes are then interchangeable between the two. This can be overcome by using your camcorder as a playback deck, either directly or by dubbing it into your home deck, but it's generally easier if you can simply pull a tape from the camcorder and use it in your VCR.

Another decision has to be made concerning size. The two basic choices are full-sized and miniature. Each has advantages and disadvantages.

The full-sized camcorder is heavier and thus more difficult to carry around. That *can* be an advantage in that something larger and heavier is also easier to hold steady; the steadier the camera, the steadier the recordings.

The extra size makes it possible for a part of the camcorder to rest on your shoulder. One of your hands (usually the right) slides into a strap, with that thumb controlling the on/off recording button. The other can be (should be!) used to hold the camera just behind the lens. In a sense, you become a tripod mount for the camera, with your shoulder supporting one point,

FIGURE 11–2 Place the camcorder on your shoulder and hold it with both hands.

and your hands securing the front of the camera in two places.

This isn't possible with the miniature formats. The VHS-C and 8mm camcorders are so small that using your shoulder as a brace for steadiness isn't possible unless you get an optional device to serve for that function. The images recorded *tend* to be less steady. However, the miniature formats bring with them a much lighter weight. It's easier to carry these camcorders for longer periods without strain.

Lux

Another consideration is the sensitivity of the camcorder. The standard unit of sensitivity measurement is *lux*. This is a metric unit, representing the amount of light from a standard candle spread across a 1 square meter surface, with the candle 1 meter away from that surface. It equals, roughly 10–11 footcandles (the light of that candle spread across 1 square foot of surface, with the candle 1 foot from that surface). A camera rated at 10 lux is theoretically capable of picking up and recording an image lighted with nothing more than candlelight. The lower the rating number, the more sensitive the camera.

Don't let the ratings fool you. Virtually all come about by tests under optimum conditions and accept images of minimal quality. In other

FIGURE 11–1 A full-sized camcorder is easier than a small one to hold steady.

words, if the camera can pick up *any* image at a particular light level, however poor it is in quality, the manufacturer can claim that level of sensitivity.

The only way to test the "honesty" of those numbers is to try the camcorder under various conditions to see what it can do. Unfortunately, this isn't usually possible. Even in the stores that sell the equipment, chances are good that the best you'll get will be to see a professionally made "demo-tape."

If at all possible, try to get a more practical demonstration of the camcorder's abilities. Put in a blank tape and try some quick recordings under various conditions. Shoot some scenes inside the store, then outside (or at least through the window). Don't forget to shoot into some dark corners to test the "low light" capabilities.

Video Pickup

You don't have to be concerned with this, but because it's often a part of the sales pitch you should at least know what the terminology means.

The first video cameras used tubes, somewhat like small and reverse versions of the picture tube of your television set. As light struck the chemical coating of the tube, electrical impulses were created that could in turn be changed into magnetic pulses, which could in turn be recorded.

Tube pick-ups are still used in some studio

FIGURE 11–3 One lux is the amount of light of a standard candle 1 meter from the surface, spread across a surface of 1 square meter.

cameras where conditions can be controlled. For home and portable use, they have been all but replaced with solid state pick-ups, such as the CCD (charge-coupled device).

The latter is smaller, lighter, faster (more sensitive to light), and tougher. The camcorder using it can be the same. It's less prone to physical damage and also much less prone to things like burning.

A tube pick-up camera, for example, can be permanently damaged if a bright spot of light hits one portion over a period of time. (How long depends on how bright.) The solid state pick-up isn't nearly as sensitive to this kind of damage.

Standard Features

Virtually all camcorders today come with certain features as standard. Auto-white, or auto-color, will set the filters in the camcorder to adjust to the quality of light. Many people don't realize that different light sources have different colors. A household incandescent bulb is red in comparison to sunlight; shade is blue in comparison. With a film camera, you have to match the film to the source of light, or use filters on the lens to make the adjustment. A camcorder has a built-in *stripe filter* to take care of things, either manually or automatically.

Auto-iris adjusts for the amount of light. Bright sunlight is obviously of greater intensity than a reading lamp. The camera needs some way to adjust for the amount of light on the scene. Auto-iris does this for you.

Auto-focus is self-explanatory. A beam is sent out, bounces off the subject, comes back to the camera, and the lens is automatically adjusted so that the subject is kept in focus.

The problem with all "auto" features is that they can be easily confused or even fooled. For example, if the scene you're shooting is lighted from different sources, the camera won't know which is primary. It could end up adjusting to one source while the other "discolors" the scene. Or you could be shooting video of a person standing on your patio, but with a bright field behind. The camera might adjust itself to the brightness of the field and throw the subject you really want into darkness. The same can happen with focus.

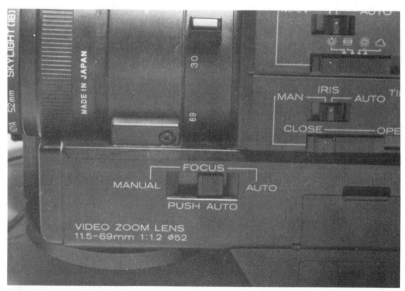

FIGURE 11–4 The auto-features of your camera can be fooled. Each of them should have a manual override.

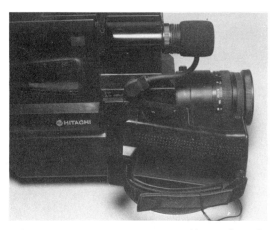

FIGURE 11-5 The power zoom control is usually on the grip so your first and second fingers can operate it.

Be *sure* that the camera you pick has a manual override for each of the automatic features. Preferably, the auto–white (color balance) should have both a manual setting *and* a "lock."

This latter allows you to let the camera set itself and then "lock" onto that setting even if the lighting conditions change. This can be a very important feature because few camcorders have a color viewfinder—only monochrome. This means that unless you connect the camcorder to a color monitor, manual settings will be largely guesswork. Yet leaving the camcorder on automatic means that the circuits will keep trying to adjust for different kinds of light. By having a "lock" feature, you can let the automatic sensor adjust the camera to the primary lighting source and then keep that setting.

Another standard feature is power zoom. With the push of a button—usually located on the grip so that your first and second fingers can activate it—you can zoom in or out. The standard has been a 6–to–1 zoom, which in effect brings you six times closer to the subject without moving. More and more camcorders are being made available with 8–to–1 zoom and 12–to–1 is starting to appear.

This is another feature you should test before writing out your check. With all home cam-

corders, the lens is adequate at best. (Really top quality lenses are *expensive*!) And a zoom is more or less a compromise between various focal lengths all squeezed into a single body for convenience rather than image quality.

Test the lens at various settings. You're looking for focal lengths that provide a blurry or otherwise less than adequate image. Zoom in and out several times. It's a good idea to try stopping for a few seconds at various focal lengths, but as a general rule, if the scene stays in focus at full zoom and at minimum zoom, the lens is doing a fine job.

As with the lens, the camcorder's microphone is usually no more than adequate. It will do the job for you as long as your needs aren't too exacting. It should be detachable or have a separate external microphone jack. This way you can use a different microphone if you wish.

The audio on virtually every home camcorder is put through an AGC (automatic gain control) circuit, which theoretically adjusts the volume automatically. As with other automatic features, it's nice to be able to override the automatic and go to manual or to at least shut off the microphone without having to unplug it. Unfortunately, very few manufacturers have managed to figure out that there are times (such as during a heavy wind) that the audio needs to be closed down or shut off. This only makes

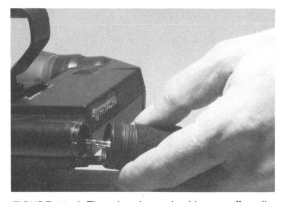

FIGURE 11-6 The microphone should come off easily, and have a standard jack (1/8 inch).

it all the more important that you can disconnect the microphone quickly and easily.

Other standard features are things such as audio/video inputs and outputs, viewfinder, review, and a time/date stamp. All of these can be important. How important depends on how you will be using the camcorder.

No matter what, it should be fairly easy to put signals into, and take signals from, the camcorder—both preferably without the need of bizarre or exotic connectors. Without this, the unit is good only for direct recording, but if you can patch into (or more importantly, out of) the camcorder, it can also serve as a VCR deck.

The viewfinder should be clear and sharp and have some kind of focusing control. The vast majority are monochrome, which is a disadvantage in that you're capturing *color* images; but if you want a color viewfinder, expect to pay a considerable amount.

A review button allows you to "go back" a few seconds to see what has been captured. Lacking this feature, you have to come out of the "camera" mode, go into the "VTR" mode, back up the tape, play it, stop, switch back into "camera," and HOPE that you end up in the same spot on the tape.

The time and date stamp, driven by an internal clock, is one of the handiest features

FIGURE 11-8 An electronic viewfinder.

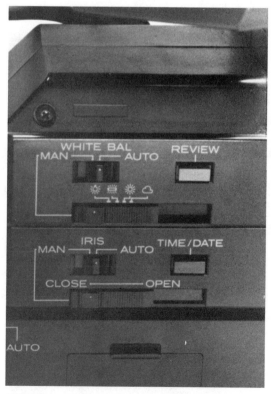

FIGURE 11-9 Standard controls of the camcorder should include a 'Review' and a time/date stamp.

FIGURE 11-7 Audio/video outputs, with standard jacks, are a must if you will be using the camcorder as a playback unit, such as for dubbing.

for homeowners—especially those with kids. In a way it's like a miniature (and highly limited) character generator. To the best of my knowledge, all camcorders have this feature, but check the unit you are considering just to be sure.

Other Features

The number of other features available grow almost by the day. These begin with the same kinds of features available on deck VCRs (see chapter 3) such as flying erase heads, stereo, etc., and goes on to include so many things that an entire book would be needed just to describe them.

Some camcorders come with a built-in character generator. This allows you to type in titles and sometimes even to position and size them. Such a feature is limited due to size, but can make adding titles easy and much cheaper than trying to do it with an off-board character generator.

Some camcorders come with a separate "Fade" control. This makes fading in and out much easier. However, you can perform the same effect by putting the iris control on manual and sliding the control to close the iris a little at a time. (Either way, and as with any effect—including zoom—use it sparingly.)

Becoming more popular is the "fast shutter." This feature means that the electronic pick up of the camcorder can fill very quickly and then freeze. The result is much like using a fast shutter speed on a still camera. Action is frozen.

With a standard camera, if someone is moving quickly, even a freeze frame on the VCR can show blurry edges. The reason is that the effective shutter speed is, at best, 1/60th of a second and only 1/30th of a second for a full double–sweep frame. This simply isn't fast enough to catch, say, the swing of a golf club or a karate practitioner's kick. A camcorder capable of capturing motion at 1/1000th of a second will be able to stop the motion.

A few camcorders now come with a single frame advance feature. This is of little use to the average user, but is absolutely essential if you plan to use your camera to create animation.

FIGURE 11–10 Some camcorders have a bult-in character generator to allow you to add titles.

Another field now coming into being is digital video. So far the cost has been prohibitive. Eventually this will almost certainly be the standard. Digital recordings tend to be sharper, but more important they can be manipulated much easier. Various kinds of special effects, for example, are impossible without resorting to digitizing. Yet another advantage is that copying digital signals doesn't carry the inherent losses involved with dubbing the standard analog–type signals.

OTHER VIDEO EQUIPMENT

We now come to another subject that could fill a book (or two) all by itself. A few years ago a handful of paragraphs would have been enough.

The real key to buying any consumer-grade equipment is to realize that you will *not* be able to remake *Star Wars* with that $499 Special Effects Generator—nor with the $1500 version. If you could, that movie and others like it wouldn't cost millions to create.

If you recognize the limitations, you won't find yourself investing in equipment only to find yourself frustrated. As always, it's best to have the equipment at least demonstrated before you spend your money.

Before you begin searching, spend some time reading magazines devoted to the field, such as *Video*. Pay attention to the ads—but not too much. Not unless you keep in mind that the devices probably won't do what you might expect from the ads.

Lenses and Filters

Even though the standard camcorder comes with power zoom and macro (close–up) features, there come times when something more is needed.

Lens filters are available in most video equipment stores and all photographic supply stores. When you buy your camcorder, also invest in one lens filter. This won't be used to

FIGURE 11–11 Lens filters.

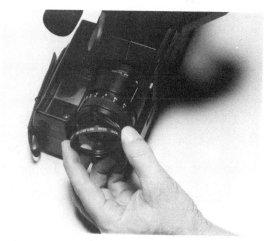

FIGURE 11–12 Invest in at least a UV-Haze or Skylight filter. This is to protect your lens.

Camcorders and Other Video Equipment **101**

"filter" anything, really. Its function is to protect the lens. With this filter in place, dust, and other contaminants will never touch the camcorder's lens. If any cleaning is needed, it will be of this filter not the lens.

The most common for this purpose are the UV–Haze and Skylight filters. Both are almost transparent and will not interfere in any way with the images you record. However, if you *want* to interfere with that image, you can buy a variety of lens filters to change the color or to create other effects. The number of possibilities is nearly endless.

In addition, and of more value to most people, are auxiliary lens attachments. A 2X converter, for example, doubles the effect of the zoom. If your camcorder has a 6:1 zoom, a 2X converter will turn it into a 12:1 zoom.

On the other end are close-up lenses. The macro feature available as standard on many lenses is all too often difficult to use. If you wish to do a lot of close–up work, it might be worth your while to invest in an auxiliary lens that allows you to do close–ups without going into macro (and thus keeping more control).

Still other lenses (and filters) allow you to create other effects. One lens will give you a "fisheye" effect. Another will split the image into multiple images. Still another will take points of light and turn them into "stars."

Lights

Photography and videography is nothing more than capturing reflected light. Obviously, that means that there has to be light so it can be reflected back to the recording camera. Within limits, the more light you have the better.

Once again you have a variety of choices. The camcorder's ability to adjust to different sources provides that. You can use sunlight, incandescent or even fluorescent. The only trick is to try to make it all the same for the same scene.

If you're going to use AC to power the lights, your choices expand even farther; but, because one of the great advantages of the camcorder is portability, most of the "video" lights you'll find will be battery powered and most of those are quartz-halogen.

These bulbs produce a brilliant and even light at a lower temperature than some other kinds of incandescent bulbs. They do it with uniformity of quality throughout the life of the bulb and at a lower draw on power. This makes them almost perfect for use with a battery pack.

The two disadvantages are cost and delicacy. The bulbs are expensive, made more so by a relatively short life (a bulb rated for 50 hours is very good). Meanwhile, even a fingerprint on the outside of the bulb can ruin it.

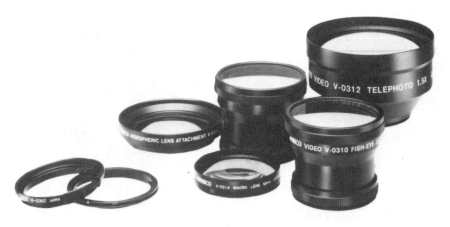

FIGURE 11–13 Auxillary lenses. Courtesy Ambico, Inc.

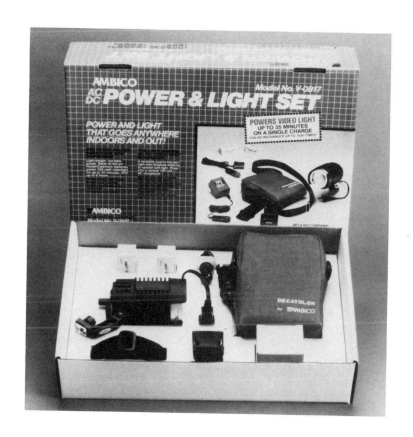

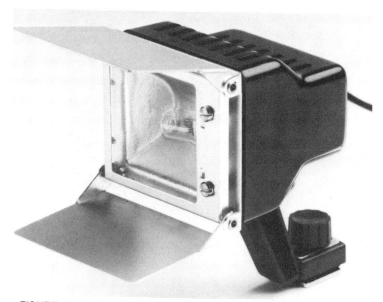

FIGURE 11–14 Portable video lights.

Microphones

The microphone that came with your camcorder will do an adequate job under most circumstances. Like the lens, it's meant to be compromises between cost, overall efficiency and overall use. But, put a subject 30 feet away, try to accurately record the sound of subjects all around a room at different distances, turn the camera away from the speaking subject, or even try to make a recording when the ambient (background) noise is high, and it just won't work very well. The solution is to use a different and/or better microphone suited for the job at hand. Have the unit demonstrated before you buy it and be sure that it will do what you want.

Microphones are made specially for video cameras. These include wide-angle, telescopic, and even "focusing zoom" mikes. You can also buy cordless microphones, with the mike and a transmitter attached to the subject and a receiver plugged into the audio input of the camcorder. The nice thing about these is that they are already set for the home camcorder. The disadvantage is that your choice is limited.

Adaptors can be purchased to plug just about anything into your camcorder. The standard input of the camcorder is a 1/8th inch pin. Standard on most microphones (other than those designed for home video use) is a 1/4 inch phone plug. You can use an adaptor to get it to fit. The only problem remaining then is to be sure that the impedances match. (The camcorder is almost always high impedance.)

The great advantage of wireless microphones is portability. If the speaker points to the side, and you pan in that direction, the audio portion will continue without dropping out. More important to some is that there are no wires running between the camera operator and the microphone.

One of the problems with wireless microphones is an overrating of their capabilities. Much like the "lux" rating of the camera, a wireless microphone rated for "50 feet" will probably give marginal quality at such a distance.

These units use very low power transmitters/receivers. With rare exception, their effec-

FIGURE 11–15 Cordless microphone Courtesy Azden Corp.

FIGURE 11–16 An audio mixer.

tive range is 20 feet or less and even then you might notice that the audio quality is "tinny" or otherwise imperfect.

One final note on audio—there come times when you want to make some comments about a recording while dubbing it or perhaps you want to mix in some background music. The way to do this is with an audio mixer. This device allows more than one audio input and then combines them into a single output. The least expensive allow you very little control of the volumes in the various channels. As you step up, you can control the volumes to the point of being able to fade in and out.

Rewinders

An audio cassette can be flipped over. This isn't true of a video cassette. Each time you come to the end of a playback, you have to rewind the tape. Although every VCR allows you to do this, having a separate rewinder has some advantages.

1. It reduces the strain on the motors of the VCR. Replacing those motors is expensive. Replacing a rewinder can be as low as $20.
2. You can be watching another video while rewinding the one you just watched. Even though the time needed for rewinding a tape is only a matter of minutes, sometimes the convenience is worth the expense of having a rewinder.
3. Some rewinders come with the ability to clean the tape. This is perhaps most important, especially if you plan to rent movies often. There is no way to know where those movies have been. If they were run through a dirty machine, they will very likely have picked up some of that filth, which means that they'll transfer it into your machine.

 If this is a concern for you, be sure that you get a unit that will go in both directions—fast forward and rewind—and will clean in both directions. In any case, if cleaning is one of your priorities, be sure that the machine cleans *both* sides of the tape. Clean-

ing just one side does only half the job, which ends up meaning that it doesn't really do the job at all.

Tripods

A full-sized camcorder can be held more steady than can one of the small versions. Even then, no matter how steady you are, a tripod is more so. Use one whenever possible. You'll find that the quality of your recordings will increase. Not only will the tripod hold the camera steadier, it reduces the temptation—and the ability—to jerk the camera in all different directions.

The tripod you get must be strong enough to hold the weight of the camcorder. In a very real sense, it should be stronger than you need. There are many tripods available designed solely for use with small 35 mm film cameras. These are rarely suitable for video work, especially if your camcorder is one of the larger, heavier versions.

The tradeoff for strength is weight. Generally, the stronger it is, the heavier it is. This can be an advantage for those times when maximum stability is needed; or it can be a disadvantage if you are going to be carrying it along with you up the side of a mountain.

FIGURE 11-17 A rewinder can save the motors of your VCR or camcorder. The better ones will give you the option of battery or AC power, and will also clean the tape.

Camcorders and Other Video Equipment **105**

The legs should extend easily and lock into place. Even at full extension, the tripod should not wobble, even when bumped.

The two basic motions are side-to-side and up-and-down. Each should operate smoothly, and lock securely. There should be no "rough" spots in either movement.

Enhancers, Editors, and Special Effects

There are ways to manipulate the video and the audio, both during recording and afterwards (either during playback or, for a permanent change, during dubbing).

The most simple is a signal booster. Its function is to increase the signal level to overcome (at least in part) the inherent losses during copying. Some of these are nothing more than inline signal amplifiers. Others also handle and defeat copyguard systems.

These latter carry a warning with them. Their advertised function is to remove the jitter sometimes seen when a copyguarded tape is played back. (In some cases, the copyguard signal is overpowering. If your equipment is sensitive in the first place, you may find it virtually impossible to watch certain tapes.) As a legal warning, copying tapes without permission is a violation of law.

A step above this is the signal enhancer. This unit does more than just boost the signal. It can also modify it in certain ways. Depending on the complexity and quality of the unit, it

FIGURE 11-18 Also handy in making dubs is a device that boosts the signal, and thus reduces signal degradation due to inherent losses.

might boost and control the signal as a whole, or in parts. For example, the better units will give you control of color intensity, hue, brightness, and other features. Top quality units, approaching "professional" may even give you control over individual colors.

It's important that you keep in mind how the unit works. It will *not* perform miracles for you. If the original image is of poor quality, boosting the signal is probably going to make it look worse rather than better.

A step up and in a slightly different direction, from an enhancer is a so-called *special effects generator*. Simple ones provide only a means of "wiping" in various directions, with various patterns, and to and/or from various colors. How many choices you have depends on the complexity (and generally cost) of the device.

A "wipe" is a fade or cut from the normal scene to something else. A good quality SFX generator (or *SEG*) will allow you more options than you'll ever need or use.

It might also let you change colors (shifting the entire scene into red, for example), switch colors (red becomes blue, blue becomes black) and otherwise change the original recording.

The greatest problem most people come into is in expecting the device to do something it can't. Mention "special effects" to most people and they'll instantly think of space ships, explosions and dramatic video graphics. They buy a special effects generator, expecting to be able to create a spectacular movie, and come away disappointed because all they can do is cause one scene to disappear in a zagged diagonal and the next to appear as an expanding oval.

For most people, the cost of one of these units is rarely worthwhile. It will either be used only now and then, or will be so overused that the resulting videos become almost absurd.

Another kind of graphic special effect is titling. You can also print or paint a sign and videograph it. Some camcorders even have a feature to make this kind of thing seem to scroll up the screen.

You can buy a camcorder with a built-in

FIGURE 11-19 Enhancers and processors can help to 'clean up' a recording. Courtesy MFJ Enterprises

Camcorders and Other Video Equipment **107**

FIGURE 11–20 Special effects generators are fine for adding a special touch. The main caution is recognizing the limitations of the devices

character generator. For those camcorders without this feature, and for better control (generally), an external character generator will let you type in titles. The better ones allow you to adjust size, type style, and color (of both lettering and background) to suit. A few stand-alone units exist. Others must be fed through a home computer.

FIGURE 11–21 A character generator can be used to create titles. Courtesy MFJ Enterprises

FIGURE 11-22 A video editor helps to control the VCR while making dubs. Courtesy Azden Corp.

As a final note is something that is beyond the budget of most. This is the video editor. The cost for one that really "does the job" can be in the thousands. It's function is to provide greater control over the tape(s) being dubbed onto a final copy. To do this, it has to be capable of handling the tape frame by frame, if need be, and without producing "glitches" between the cuts. Usually a manual control allows the user to advance or reverse the tape one frame at a time to find the exact spot.

SUMMARY

Not all that long ago "home video" was nonexistent. The best you could get was film with a strip of magnetic tape for the sound portion. This was expensive! Today all of that has changed. The quantity, quality, and diversity of video equipment grows almost by the day. It's a not-too-sad fact that whatever you buy today is likely to be virtually obsolete 5 years from now.

Camcorders come in the same format choices as VCRs. Normally you are better off matching the camcorder you buy with your home deck. But if a camcorder of a different format has features you prefer, you can always cable the two together for dubbing.

There are a number of standard features that come with camcorders. Almost all these days will boast of the ability to pick up scenes in low light. This is rated in *lux*. A 6:1 power zoom lens is still common, with 8:1 and even 12:1 quickly taking its place. Automatic features that have the camera adjusting itself to light quantity and quality, focusing distance and sound intensity are all standard.

Becoming standard is the "fast shutter," which allows you to capture fast motion without blur. Coming is a color viewfinder and digital recording, with the latter being more able to handle special effects. Digital can also make copies without the inherent signal losses of the presently standard analog methods of recording.

You can add just about anything you wish

Camcorders and Other Video Equipment **109**

to your system. A variety of lenses are available to let you do anything from videographing paramecium to distant stars. Lighting systems, some as portable as the camcorder, let you videograph scenes without having to worry about time of day. External microphones improve the audio quality and/or let you get a distance from your subject without having wires between.

Once the recording is made, you have still more possible choices. You can manipulate the recording in an almost infinite number of ways, depending on how much you're willing to spend.

Chapter 12

Camcorder and Video Equipment Maintenance

Taking care of all video equipment is similar to taking care of VCRs. The rules are basically the same, no matter what the piece of equipment. The only real difference is that a fair amount of video gear is difficult to access internally. Instead of being held together by screws, the case might be pinned or rivoted. That doesn't mean you're totally helpless. You can still perform at least a degree of maintenance, troubleshooting, and even repairs.

If you haven't already done so, review the appropriate chapters elsewhere in the book.

- Chapter 2 is on safety—yours and the equipment's. This is one of the most important chapters in the book and should be reviewed regularly.
- Chapter 7 for maintenance tips
- Chapter 9 for troubleshooting techniques

They'll also tell you a lot about what to do with other kinds of equipment.

PREVENTION

As always, the best way to take care of problems is to prevent them from *being* problems. Proper maintenance steps, will help to do this. It can mean the difference between a camcorder that gives you wonderful recordings and one that causes nothing but trouble.

By its nature, a camcorder is portable. That often means that you lose control of the environment in which it is used. It also means that certain new physical dangers can be a concern.

There will almost certainly be times when you'll be shooting under less than perfect conditions: the air out in the yard might be a bit too dusty; the humidity might be high; or conditions might be worse yet, such as shooting in a dust storm, or finding yourself in the mist of a waterfall.

The best way is to avoid situations that can cause damage whenever possible. At very least, find the safest spot. For example, you might be able to stand by a tree and let it block some of the dust or mist.

Don't forget your own safety. If you position yourself in a place where you can be bumped or can fall, not only can the equipment be damaged but so can you.

When the camera isn't in use, keep it inside a case or bag. You might find use for both, actually. A hardshell case provides maximum protection of the equipment, but often requires

that you disassemble the camcorder. While this might be fine for transport or storage, and is to be preferred, it also means that you have to take the time to assemble the parts before you can shoot.

A flexible bag doesn't provide nearly the protection of a hardshell case (although it will keep the dust off), but if you get one large enough, it can hold the fully assembled, ready-to-go camcorder.

This can be especially important if you have young children. You won't always have the time to assemble the camcorder. Children do things on the spur of the moment, which means you have to be ready just as quickly.

Many make the mistake of simply keeping the camera ready. Don't. Invest in a bag. Use the hardshell case for transport or longterm storage, but when you need to get at the camera quickly, a camera bag will allow this and still provide some protection.

Another critical investment is a filter for the lens, such as a Skylight or UV–Haze. The purpose isn't as a filter but as protection for the lens. The two mentioned will not change the image. They are almost clear. The cost will be, depending on size, between $5 and $20, which is much less than the cost of replacing a damaged lens.

Not only will this filter protect the lens from physical damage, it will protect it from contaminants. Even if the air *seems* clear, it's actually full of dust and other things that can damage the delicate lens, and the coating on this lens. With a filter over the lens, it will be the filter that gets dirty—and it will be the filter you clean, not the lens.

As with your VCR deck, use only good quality cassettes. This is even more important with your camcorder because the camcorder is more difficult to clean. It's also more difficult to handle things like tape tangles.

In all, do everything you can to keep the amount of cleaning needed to a minimum, and

the amount of protection of the equipment to a maximum.

CAMCORDER CLEANING

Keeping the outside of the camcorder clean is fairly easy, especially if you keep it in a case or bag when it's not being used. This will reduce the amount of dust that gets on it—and in it.

Even when it's out of the case, keep the lens filter in place at all times, and the lens cap on except when you're shooting. This is both to reduce the dust and contaminants that will get on the lens, and to protect the lens from possible physical damage.

With all your precautions, you'll still need to clean the camcorder outside and in. The greatest enemies are dirt, water, and carelessness (not necessarily in that order). When performing any cleaning, keep these things in mind. Your goal is to remove the dust and other contaminants, not just move them around, and to do so without adding new problems like getting things wet or broken.

Overall cleaning can be done with a clean lintfree cloth. It should be dry for most things or just slightly damp. (*Never* put a cloth dampened with water inside! Much better, inside and out, is to dampen it—slightly!—with pure alcohol or freon.) Wipe the outside, with the cassette door closed. Swabs can be used to get the dust out of spots that are too close for the cloth.

Next, open the cassette door and clean the platform. Remember that you're trying to get the dust out, not push it farther in. If the cloth is dampened slightly with a little alcohol (*not water!*), it will pick up the dust rather than move it around. Even then, pull the cloth toward you and away from the inside, and do so gently. Vigorous movement can "kick up" dust.

With some camcorders, the cassette door can be removed by taking out some screws. With most this isn't possible. This limits access to the interior. You'll be able to reach some

FIGURE 12–1 Don't forget to clean the loading platform.

parts with long–handled swabs. As always, use *only* pure isopropyl alcohol or freon, and that *only* with the foam-type swabs. Cotton–tipped swabs can leave threads behind.

Use the swabs to clean those parts you can reach safely. Remember that you're trying to let the solvent do the cleaning. Only very slight pressure is needed—just enough to have the swab tip stay in contact with the part to be cleaned. Do not try to scrub with the swab.

As another reminder, do not use alcohol on the rubber parts. It will dry them out and cause premature aging. For these parts, use only cleaners safe for rubber, such as freon.

Head Cleaning

It's possible that even though you can touch the head assembly with the swab, you won't be able to reach in with a finger to turn it. This makes cleaning the video heads difficult or impossible unless you use a cleaning cassette.

If this is the case with your camcorder, make it a point to get the best cartridge possible, and of the "wet" type. With this kind, a fabric ribbon is wetted with a special cleaning fluid. The cartridge is inserted and "Play" is pressed.

Usually 5 to 10 seconds of "play" is sufficient. Less may not do the job; more increases the risks of causing more harm than good.

In any case, *never* reuse any of the fabric. Once the ribbon is "played" through, discard the cartridge and get another. This should also serve as a warning on purchasing a cleaning cartridge. Some use the "endless loop" design, recycling the fabric tape inside. Cost of materials during manufacture is a few pennies lower, but all this does is to put already contaminated fabric across the heads.

Lens Cleaning

Just as delicate as the head assembly—and *more* delicate in many ways—is the lens. It's made of glass and given a coating to reduce

FIGURE 12–2 Some interior cleaning can be done with long-handled swabs, but *be careful!*

FIGURE 12–3 With many camcorders, access to the interior is limited. You may have little choice but to use a head cleaning cartridge.

Camcorder and Video Equipment Maintenance **113**

certain optical problems. Both scratch easily; neither can be repaired. If there is damage, the only solution is replacement of the lens, an expensive task!

At the same time, the lens is being exposed to a variety of contaminants. Not only will dust collect there, so will all the things that concern environmentalists. At times it will seem to be coated with a layer of scum.

Anything on the lens will degrade the image captured. At the same time, cleaning away that "anything" represents a potential danger. (Wiping the dust can mean grinding it against a surface that is all too easily scratched.)

Once again we come to that critical investment of a lens filter. This filter protects the much more expensive lens beneath. If a rock is kicked up and causes a crack, a few dollars for the replacement takes care of it. Meanwhile, this filter "absorbs" other problems. When it comes time for a lens cleaning, you'll be cleaning the filter rather than the lens of the camera. Any damage will be to the replaceable filter rather than to the not-so-replaceable lens.

The first step is to blow off as much of the dust as possible. Use a can of compressed air for this, such as those used by photographers. (Do *not* simply blow on the lens. This will put droplets of your own moisture on the lens.)

Lens cleaning kits are available in photographic stores. The ones from stores that sell glasses are not necessarily sufficient. Although the fluid and tissues are meant for optical glass, they are not always meant to take care of the sensitive coating given to camera lenses.

Using lens cleaning fluid or not is a matter of preference, and controversy. Some say that even those fluids meant for photographic (coated) lenses can cause harm. Others say that that is the only way to get the lens really clean.

Your solution is to get *only* the best kit, with the best tissue and the best fluid and use them as seldom as possible. Once again, if you have a filter over the lens, even this becomes irrelevant. With that filter kept in place, you'll never have to touch the lens of the camera.

TROUBLESHOOTING

Troubleshooting of a camcorder is very much the same as with a VCR with one large exception. With many camcorders, you can't easily get inside to do the tests. This may also be true of other video equipment. With limited access, what you can do is equally limited.

Inspect your equipment carefully. If there are screws holding the case together, you can probably achieve at least a partial disassembly.

FIGURE 12–4 Use great care when cleaning the lens.

Even if there are screws, proceed carefully. As has been mentioned before, most of the screws that come through the case simply hold it together. Occasionally a screwhead is actually holding something inside or might be for adjustment. A careful examination will let you know.

At times like this, the best advice is: "When in doubt, *DON'T!*" At least don't unless you can afford to replace the equipment. (There are times when a piece of equipment is useless as is, and isn't worth paying the cost of repair. If you're in a position of having to replace it anyway, you can take some chances that are otherwise inadvisable.)

Let's first assume that you cannot gain access to the interior. Check the obvious. Is the battery charged? If the equipment is AC powered, is it plugged in? Don't assume that because there is some power that there is enough. There's little sense in tearing a camcorder apart just because you haven't charged the battery, or have plugged the AC–adaptor into a dead outlet.

A good example is a camcorder that records for a few seconds and then shuts off. For that brief time everything seems to be operating normally. Because of this you might assume that power is not the problem, yet that is just what is happening. The battery is discharged. Shutting things off will let it drag up that few seconds of power, but it won't last.

Try recharging the battery. That will test the battery, the charger and eventually the incoming power to the camcorder. If the battery won't take or hold a charge, attach the camcorder directly to the AC adaptor. If everything works now, you know that the battery needs to be replaced. If it doesn't, it's possible that the AC adaptor has gone bad. A simple VOM test of the outputs will tell you.

Much the same is true of other video equipment as well. Even if you can't get inside, you can probably test the incoming power supply at least to a degree. If it plugs in, is the wall outlet good? If battery powered, test the batteries either with the VOM or by replacement. Are all connectors in place—*in the proper place(s)*—and secure?

Some video equipment has relatively complex connection schemes. It's easy enough to mix up just audio and video. If you're using your camcorder as a playback deck to dub into your home VCR and you get no signal, look to see if the connectors are where they are supposed to be. The more complex and the greater number of cables and connectors, the more important this becomes.

Are the cables good? Testing them for continuity and shorts is simple (see Chapter 5). Even a new cable right out of the package can be faulty.

If the camcorder won't record, do you have a tape in? Is the record–protect hole covered? Is there any tape left on the reel? Could it be binding due to a warp in the cassette?

You can check all of these things quickly and easily. By using your common sense, you should be able to find out if the problem is something you can fix, or if it's time to visit a professional technician. Especially with camcorders, it's generally better to spend a little and play it safe. It's too easy to cause expensive damage. Once you have eliminated the obvious possibilities and have exhausted those appropriate things you can test safely, stop.

Your range of possibilities increases if you can get inside the equipment without causing damage. As always, begin with the obvious and proceed to the more complex slowly and carefully. Begin with a thorough visual examination. This will serve not only to spot obvious problems but will also give you some familiarity with the unit.

Inside or out, at the top of the list of "most obvious" is operator error. It might be a blow to your ego, but experts know all too well that more than half of all "malfunctions" are noth-

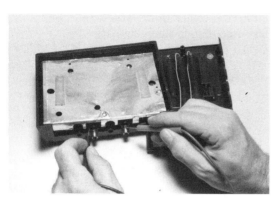

FIGURE 12–5 With some equipment you can get inside to perform some tests, such as on the connectors.

ing more than operator error. (Some put it as high as 85%, depending on the complexity of the equipment.)

Why spend $100 or more only to find that the reason your camcorder won't accept a tape is because you are trying to load it upside down?

Operator Error

Whenever I think of troubleshooting camcorder and other peripheral equipment I think of a friend who brought his camcorder and several other pieces of gear to me. He said that it was all malfunctioning.

He brought along a tape he'd made. After just a few minutes of viewing, I felt the need

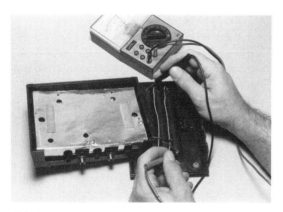

FIGURE 12–6 You might also be able to test the power source.

for motion sickness pills. Every scene was jerky and blurred. He put the blame on the camera. The real blame was that he hadn't learned the simple trick of holding still. He'd been thinking "movies mean move," and he'd done just that. Even with the camera set on automatic, he's twisted and turned and jiggled so much that the circuitry couldn't keep up.

There was no problem with the camera at all. The problem was with the person operating it. As soon as he learned to hold still, and to pay attention to things like windows, his recordings improved remarkably.

The same was true with the other equipment. He'd purchased an expensive special effects generator. He wanted a particular scene to dissolve in a slowly increasing oval. When it would only go faster than he wanted, he put the blame on the equipment. He'd ignored the control with the label "Speed."

When it comes to equipment of all kinds, one of the greatest causes of "malfunction" is nothing more than operator error or operator expectations. One of the most common examples is when there is assumption of equipment malfunction when the reds come out as being more orange, or when there are other shifts in color. If *everything* is the wrong color, even when the camera settings are correct and the lighting is good, something is definitely wrong. But, when only one color isn't quite right, you're probably looking at a problem inherent in design characteristics.

Professional 3–pickup cameras are meant to capture colors as they really are, and can be adjusted. Home camcorders have a single pickup, with the different colors being made possible through a *stripe filter*. What this means is that a compromise is being used so that the color rendition is accurate overall. Certain intense colors, such as red, will be softened so that others less intense won't flood the recording. (Even with professional 3–tube video cameras, you'll notice a shift toward the orange when reds are being videographed.)

The key is to not expect more of the equipment than it is capable of producing. What seems to be a malfunction may not be. It could be nothing more than a limitation of the equipment itself.

This is also true of external equipment. As mentioned in the last chapter, and just above in this, *special effects generator* will have some very tight limitations. If it won't do what you want, chances are good that it simply can't—or you haven't learned how yet. (In the first, can you honestly expect a $300 device to do the same job as one costing $3,000,000? In the second, if you sat down in front of that $3,000,000 unit, would you have any idea of what to do? Would you blame the equipment when nothing happened?)

SUMMARY

Taking care of camcorders and other video equipment is almost the same as taking care of VCRs. The same basic rules apply.

1. Do everything you can to prevent problems from occurring.
2. When malfunctions do occur, begin with the obvious and simple—progress slowly and carefully to the more complex.
3. Know when you've reached your limitations.

For the first, keep the equipment as clean as possible. Try to keep it out of environments that will shorten its life or cause trouble. A hardshell case provides maximum protection, but usually means that the camcorder has to be disassembled. For those times when you need the camcorder ready in an instant, at least use a bag to keep dust off.

To protect the lens, invest in a lens filter that does not change the image captured. The two most common are UV-Haze and Skylight. Both are cheap protection for the lens. Even if there is physical damage, you'll be replacing a cheap filter rather than an expensive lens. Meanwhile, any cleaning needed will be to the cheap filter.

Keep the basics in mind. Your job is to *remove* contaminants, inside and out, not merely *move* it. While you do this, you shouldn't be causing additional problems, such as getting moisture inside or causing physical damage. Use *only* pure isopropyl alcohol, freon, or some other cleaner designed specifically for the job. Use *only* lint–free and thread–free materials for the cleaning. No matter what, spend the few extra cents needed to get *only* the best fluids and materials.

When troubleshooting, begin again with the basics. Chances are very good that the cause is obvious and easily corrected. Proper troubleshooting starts with the most obvious and simple and proceeds step–by–step to the more complex.

Know your limitations. You can do what might be (to you) a surprising amount of diagnosis and repair, but you need to be equally honest with yourself as to when it comes time to stop and call in a professional.

If you wish more details on camcorders and other home video equipment, see "Chilton's Guide to Using and Maintaining Home Video Cameras and Equipment" (also by Gene B. Williams). This contains much more information, particularly concerning use of equipment to best advantage.

Chapter 13

Maintenance Log

Use this chapter to keep track of what you've done and when you've done it. Dating your repairs and parts replacement is important, especially if you intend to remove the cover only rarely and plan to perform the head-cleaning chores with a cleaning cassette.

At the end of the maintenance log is a section for recording miscellaneous things that you've had to do or have done. For example,

if a head has to be replaced or a belt changed jot down the date and the cost. Also keep a record of voltage and wire color codes.

This is also a good place to jot down operational peculiarities that you noticed, either with the machine, peripheral equipment (cameras, editors, rewinders), or certain tapes that seem to be performing differently from others in your library.

BASIC MAINTENANCE SCHEDULE

25–50 hours (or monthly)	Date								
Clean heads									
Clean tape transport mechanism									
Demagnetize heads									
Visually inspect for wear									
Check cables									
Clean contacts on plug-in boards									
Clean tape cassette cases and boxes									

BASIC MAINTENANCE SCHEDULE—
continued

300–500 hours (or every 6 months)

Check belts										
Clean underside										
Check drive gears and pulleys										
Check springs, rollers, and capstans										
Adjust torque and tension										
Check adjustable voltages										
Change silica-gel packets										
Clean tuner (if mechanical)										
Adjust tape transport (if possible—see service manual)										

1,000 hours (or annually)

Have heads aligned										
Professional checkup										

Occasionally

Repack stored tapes before playing										
Check power cord for fraying										
Reset timing devices										

Note: This maintenance log assumes that you are following a routine schedule of cleaning. Some of the steps will necessarily be skipped if you are using just a cleaning cassette. In this case, perform the steps whenever you have the cover off.

OWNER'S LOG (Miscellaneous Steps)

Action	Date	Comments

Action	Date	Comments

Action	Date	Comments

Action	Date	Comments

Action	Date	Comments

OWNER'S NOTES

Subject _____ *Date* _____

Subject _____ *Date* _____

Appendix

Using a VOM

The VOM is quite versatile, while still being easy to use. We've included this information again in a handy appendix, as you will find many uses for a VOM around the house.

Using a volt–ohmmeter isn't difficult. Actually, no home should be without one. It is one of the handiest tools anywhere for spotting a number of problems in a number of places. You can use it to check wall outlets, to check the writing in your car, and of course to help you maintain and repair our VCR.

The two basic functions of the VOM are to read voltage and resistance. Ranges in each are accessed by a selector. How many ranges are available will depend on the cost and complexity of the meter.

Almost any meter will do for normal use. You don't have to spend hundreds of dollars on a fancy meter; the inexpensive $10 VOMs available will be accurate enough for your needs. (Of course, a better meter is to be preferred—especially if you'll be probing any sensitive components.)

Measuring Voltage

Voltage is measured as either AC (alternating current, such as what comes from the wall socket) or DC (direct current, such as the voltage from a battery or the power supply and is used in most electronic circuits). Most meters have several ranges in each.

Selecting the proper type and range is important. Try to read the 120 volts AC from the wall socket with the meter set to measure 3 volts DC and you're going to have some trouble. The same applies to having the selector set at 3 volts DC when a 93 volt DC pulse is coming in. A high voltage and a low setting can make the needle instantly swing across the face of the meter and wrap itself around the stop pin. Your meter would be ruined. It is always best to start with a range setting of higher than you think is necessary.

The probes have metal tips, which means they can conduct. Be extremely careful when you are poking around live circuits. It's easy to slip and create an accidental short. Even if the current isn't harmful to you, that short circuit can destroy the delicate components.

The best way is to *attach* the probes to the test points with the power off. (This assumes, of course, that your meter has probes with clips on them.) Double check that they are where they should be, then energize the circuit. Shut down the power again before removing or moving the probes.

For your own safety, try to clip at least the ground (black) probe. This way you'll be able to follow the "one hand rule." That is, you won't have to worry about holding both probes and can keep one of your hands in your pocket.

Measuring Resistance

The other function of the VOM is to measure resistance, which is done in units called ohms. This same function is used to measure for *lack* of resistance (continuity). How to use the meter to test cables for breaks and shorts is described in Chapter 5.

Testing Individual Components

The ohmmeter side of the VOM can also be used to test individual components. The method is much the same as testing cables. You're looking for certain resistances or lack of resistances. A diode, for example, conducts electricity in one direction only. In this direction there is a very low resistance to current. In the opposite direction, the resistance is extremely high. If you don't find this, you know that the diode needs to be replaced.

This particular test requires that you first test the diode with the probes one way and a second time with the probes reversed. Also, the DC voltages you'll be measuring can be either positive or negative with respect to ground. If you see the needle move down, in the wrong direction, all you have to do is to reverse the probes.

Some VOMs have a polarity switch, usually labeled "Forward" (or "Normal") and "Reverse." Having a polarity switch comes in very handy, especially if the probes are clipped into place. It also makes testing some components faster.

The two leads coming from the meter are usually black and red. Most of the time you'll be using the black probe as the *common* or ground (−) side, with the red (+) touching the spot being tested. The common side is either some marked or known spot, or the chassis itself.

The probes are insulated. This is there to protect you. Even when you are checking a circuit with no power, make it a habit to hold or touch the probes *only* by the insulated handles. Sooner or later this habit will come in handy. Learn it early and you'll never have to learn the value of insulation the hard way.

Glossary

AC: Alternating current, such as from the wall outlet.

AGC: Automatic gain control. Theoretically keeps the signal at a uniform level, even when the incoming varies in intensity.

Align: When referring to the video heads of the VCR, the term is used to describe the process of setting the heads at the correct angle.

Amplifier: A device that boosts a signal.

Antenna: A device that is able to pick up a transmitted signal from the air. It is then fed through wire or cable to the VCR or television.

Aperture: The opening of a lens, determining how much light is let in. Also called *iris*.

Audio: That section which handles the sound portion.

Autofocus: A circuit that allows the camcorder to automatically focus.

Autoiris: A circuit that allows the camcorder to automatically adjust itself to the quantity of light.

Autowhite: A circuit that allows the camcorder to automatically adjust itself to the quality of the lighting and color of the scene.

A/V: Audio/video.

Beta: The first home video format; developed by Sony.

Cable: The wire assembly used to carry a signal from one place to another, such as the RF cable used to take the signal from the VCR and bring it to the television set. It is also used to describe a company or system, usually commercial, that supplies a television signal to the home by using cable instead of air waves.

Camcorder: A combination of video camera and recorder in a single package.

Capacitor: An electronic component used to store a charge. This makes it useful as a filter for "smoothing" AC ripples. And since it will pass AC signals while blocking DC, it is sometimes used to remove unwanted AC signals.

Capstan: A pin, rod, or motor shaft that turns, often made of metal.

Carrier: The underlying signal on which the information of a transmission is impressed.

Cassette: Also called a "cartridge." Both describe the case, tape and the various parts that hold it all together.

CCD: Charge-coupled device; often used as the imager for a camcorder.

CCTV: Closed circuit television.

Chip: More correctly called an "integrated circuit" (see "IC" below).

Chrominance: Color.

Common: The ground of a circuit, or the common path by which electrons return to the source (such as a battery or power supply).

Control Track: Pulses recorded linearly on the video tape that control the video heads and related circuitry during playback.

CRT: Cathode ray tube—the correct name for the picture tube of a television.

DC: Direct current, such as is supplied by a battery. It flows in one direction only, unlike AC which flows back and forth.

Depth–of–field: The range of focus at a given lens opening (aperture). The wider the opening, the narrower the depth of field (the smaller the range in which the subject is in focus).

Dew Sensor: A special device in some VCRs that signals when the moisture level inside the machine is dangerously high.

Diode: A basic electronic component, often used to convert AC to DC due to its characteristic of allowing easy flow of current in one direction but not the other.

Distortion: Impurities in the signals, most often caused by interference or by inherent flaws in the circuit.

Distribution Amplifier: A device that both boosts the signals and splits them so they can be used by more than one set.

Drop-out: Loss of signal. A common cause is deterioration of the tape.

Dubbing: To transfer a recording from one tape to another.

Edit: To change. A number of editing devices are available which allow anything from basic dubbing to complex modification of the original recording.

8mm: A relatively new miniature format; developed by Sony.

E/V: Electronic viewfinder. Like a miniature television, it displays to the camera operator what will be recorded.

Flagging: A term used to describe the apparent bending at the top and bottom of the screen.

Flutter: Distortion, generally concerning higher frequencies in the audio.

Frame: A single picture image. When many are put together they give the sensation of motion.

Freon: An inert substance, often used for cleaning because it does not cause a chemical reaction and evaporates quickly with no residues.

Frequency: How quickly an AC signal shifts between positive and negative. The electricity coming into your home does this 60 times per second (60 cps). A radio frequency signal does it thousands or millions of times per second.

Ghost: An echo of the original image, caused by a reflection of the original signal.

Glitch: Interference, generally caused by relatively low frequencies, that causes a bar to move across the picture.

Ground: See "common."

Helical: A spiral–shaped motion, such as used by the path of the video tape across the recording/playback heads.

High-Z: High impedance, such as the microphone of most camcorders.

Hooking: See "Flagging."

Horizontal: Flat—from left to right.

HQ: High quality, referring to the special circuits designed to produce a better image. The three basic types are white–clip, luminance noise reduction, and chrominance noise reduction. A VCR listed as HQ will have one or more of these circuits.

IC: Integrated circuit. Used to describe a module that contains within it any number of basic components, making it a sort of miniaturized circuit. Sometimes called a "chip" because they often look like flat blocks of plastic.

Imager: The part of the camcorder that picks up the reflected light of the scene.

LCD: Liquid crystal display.

LED: Light emitting diode.

Low-Z: Low impedance.

Luminance: Brightness.

Lux: A metric unit of measurement of light quantity. The lower the number rating of a camcorder, the more sensitive it is.

Macro: A type of lens, or lens feature, that allows extreme close–up work.

Monitor: The television receiver; more often used to describe a special, high quality set that has no actual tuning section.

Noise: Distortion. In the audio range distortion is an "unclean" sound. In video it can be marked by streaks, splotches or other distracting signs.

Ohm: The unit of resistance.

Oxide: Simply, a sophisticated and controlled form of rust, with a chemical formula of Fe_2O_3. This is what allows the signal to be recorded and played back magnetically.

Peripheral: Equipment outside the main unit, but connected to it. Examples are cameras, editors, enhancers, etc.

PET: Polyethylene terephthalate—the technical and generic name for mylar (owned by duPont) and the plastic base of most recording tape.

Pickup: The imager of a video camera; picks up the light of the scene and converts it into electricity.

Resistor: A basic electronic component that restricts the flow of current.

Resolution: Clarity of a picture.

RF: Radio frequency. This is very high compared to the AC frequency of household current. It is the range from about 10,000 cps and up. (See "VHF" and "UHF.")

Roller: A rubber "tube" that causes the tape to move. Friction is caused by a squeezing motion of the capstan against the roller (with the tape between).

Scan: To break an overall image into component parts, which are then translated electronically so they can be stored.

Servo: A device that takes incoming power and converts it to a mechanical motion.

SFX: Special effects. A special effects generator is also sometimes abbreviated as SEG.

Shutter: Determines the length of exposure in a camera.

Signal: Voltages that carry the information. (The signal from a distant television station to your antenna is an extremely low voltage, but it *is* there.)

Signal–to–Noise (S/N) Ratio: How the wanted signal level compares to the unwanted noise.

Skew: To move at a slant from the normal motion.

Stage: A section of an electronic unit that performs a particular function.

Stripe filter: Used in a camcorder or other single–pickup video camera to separate the light into its primaries (red, green and blue).

SVHS: Super VHS. (See VHS.)

Sync (or Synch): The exact relationship between one thing and another so they operate perfectly in step. For example, as the camera scans a scene, the monitor and VCR must know exactly where to begin each frame. A sync pulse is used to keep the various things working together.

Terminate: To end, such as to connect a wire or cable, bringing to an end the signal carried by that wire or cable. (A "terminal" is where this happens.)

Threading: Loading of the tape along the correct path.

Torque: The twisting force, such as of a motor.

Tracking: Keeping the recorded signal in exactly the right place for the heads to read.

Transformer: A basic electronic component used to change one value of AC voltage to another.

Transistor: An electronic component, the basic structure of which is much like two diodes connected back–to–back. This allows it to amplify and otherwise control the flow of current.

UHF: Ultrahigh frequency. Used to describe channels 14–83 on your television set or VCR tuner.

VCR: Video cassette recorder.

Vertical: Up and down.

VHF: Very high frequency. Used to describe channels 2 to 13 on your television set or VCR tuner.

VHS: Video home system, developed by JVC (Japanese Victor Company). Presently the most popular format.

VHS-C: Miniaturized version of VHS.

VOM: Volt-ohmmeter. A tool used to test voltage and resistance.

VTR: Abbreviation for video tape recorder. This term describes *all* machines that make video recorders. VCR describes only those that use cassettes.

Wow: Distortion in sound reproduction.

Zoom: A lens with an adjustable focal length. This allows you to "move in" with the lens rather than physically.

Index